IMAGES
of America

CORONA
THE EARLY YEARS

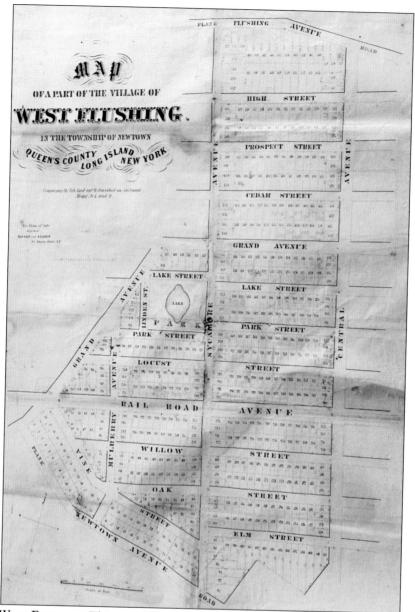

MAP OF WEST FLUSHING. This rare 1854 map of West Flushing shows the streets and avenues laid out by the West Flushing Land Company. Street names like Sycamore Avenue; Rail Road Avenue; Locust, Willow, and Vine Streets, as well as the Newtown Avenue and Flushing Avenue Plank Roads are long forgotten roadways that once added charm and distinction to the new neighborhood more than 160 years ago. (Authors' collection.)

ON THE COVER: QUEENS BOROUGH PUBLIC LIBRARY, CORONA BRANCH, 1910. One of the first locations of the Corona Branch of the Queens Borough Public Library was known as a travelling station, or travelling library, as it was temporarily set up inside of a local business awaiting the building of a permanent facility. (Queens Borough Public Library, Archives Queens Borough Public Library Photographs.)

IMAGES
of America

CORONA
THE EARLY YEARS

Jason D. Antos and
Constantine E. Theodosiou
Foreword by Burt Young

ARCADIA
PUBLISHING

Published by Arcadia Publishing
Charleston, South Carolina

Printed in the United States of America

Library of Congress Control Number: 2015939473

For all general information, please contact Arcadia Publishing:
Telephone 843-853-2070
Fax 843-853-0044
E-mail sales@arcadiapublishing.com
For customer service and orders:
Toll-Free 1-888-313-2665

Visit us on the Internet at www.arcadiapublishing.com

*To Jack Friedman (1959–2015), executive director
of the Queens Chamber of Commerce, our friend
and a lover of Queens County history*

CONTENTS

Foreword 6

Acknowledgments 7

Introduction 8

1. From West Flushing to Corona 11

2. The Railroad Comes to Town 35

3. The Birth of Corona Village 43

4. A Horseracing Legacy 89

5. Flushing Meadows 93

6. Corona by the Bay 103

7. The Genius of Louis Comfort Tiffany 115

8. Corona on the Eve of the World's Fair 121

Bibliography 127

FOREWORD

Corona is a small bridge between Flushing, Astoria, and Woodside. But for me, Corona has strings of my life in a bear hug. Sometimes pleasurable, sometimes sorrowful.

I was baptized in Our Lady of Sorrows Church at 107th Street and Thirty-seventh Avenue. Lady of Sorrows, what a sad name, but many memories, including life and death, all seemed to be housed in its red bricks. My dad, trying to make me a gentler kid, sent me to Bryant High School in Astoria, away from my Corona pals. Soon, however, I got thrown out and then it was onto St. Anne's Academy in Manhattan, getting booted out after one term. Finally, it was the Marines at 16, my pop fibbing my age to get me in.

Then onto Paris Island, Camp Lejeune, Okinawa, the Philippines, Quemoy, Japan, and then back to New York.

Soon after, I got married and we had two children. We lived at 108-64 Thirty-eighth Avenue in the heart of Corona with a mix of all nationalities, including Italians and Columbians. I remember my son had his own gang at the age of eight called the Monkeys. Tough kids but so wonderful.

I can still remember that Corona girls are the prettiest, and the Parkside Restaurant at 108th Street and Corona Avenue continues to be a great tradition. We also had the late Potash fruit and vegetable market and Leonard's Bakery, the home of the original hole in the wall gang, owned by Andy Giovingo. And then California called, but Corona had already stamped my life and has stayed with me forever.

—Burt Young

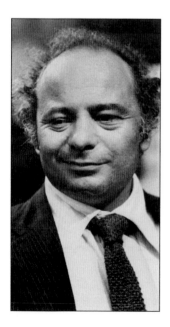

Born in Corona in 1940, actor Burt Young studied his craft under legendary acting coach Lee Strasberg at the Actor's Studio and has appeared in numerous major motion pictures, including the *Rocky* films. It was in *Rocky* (1976) that Young portrayed his most notable character, "Uncle Paulie," for which he was nominated for an Academy Award for Best Supporting Actor. He would go on to reprise the role several times during a 40-year period. Young experienced many different roles in his life, including professional boxer, appearing in 14 professional matches, all of which he won. Young has also boxed with legend Muhammad Ali to raise money for charity. Additional movie roles include *The Gang That Couldn't Shoot Straight* (1971), *Back to School* (1986) with Rodney Dangerfield, Sam Peckinpah's *The Killer Elite* (1975) and *Convoy* (1978), *The Pope of Greenwich Village* (1984), Sergio Leone's *Once Upon A Time In America* (1984) as well as numerous television appearances including *M*A*S*H*, *Miami Vice*, and *The Sopranos*. Young lives on Long Island where he has turned his passion and talent to professional painting. Young, who has completed more than 800 paintings, has a gallery in Port Washington.

ACKNOWLEDGMENTS

Our book could not have succeeded without the support of many who went out of their way to assist us. Thanks to them, the legacy of Corona will live on.

The authors would like to extend a heartfelt appreciation to Richard Hourahan, collections manager at the Queens Historical Society, whose letter of recommendation helped launch this project. Thanks also to archivist Erik Huber, who pulled dozens of Corona-related images from the vast collection at the archives of the Queens Borough Public Library (formerly the Long Island Division), as well as to rest of the library's dedicated staff. Michael Perlman and Devon O'Connor deserve to be acknowledged for their words of encouragement.

Unless otherwise noted, all images are sourced from the personal collections of the authors.

A tremendous thank-you also goes to Al Clarke of the Queens Topographical Bureau and the office of Borough Pres. Melinda Katz.

For their receptiveness and editorial guidance, we are most indebted to Sharon McAllister and Henry Clougherty at Arcadia Publishing.

Making this project even more special was the interest shown by Corona native and Academy Award–nominated actor Burt Young, who validated our book's importance by agreeing to write its foreword.

The authors would be remiss if we did not extend our gratitude to our families for their continued love and support.

INTRODUCTION

The pageant of Corona

—Vincent F. Seyfried

To William Coughlan, Flushing Bay meant a fabled childhood.

In an interview published by the *Long Island Forum* in 1978, the local chronicler hardly minced his words: "When I visit Shea Stadium to see a Mets baseball game, I often climb to the highest reaches of the stadium and look down on the scene of my boyhood—a scene that recalls many happy memories. Some of them have been more interesting and rewarding to me than many of the ball games of recent years."

Like most neighborhood youngsters, Coughlan spent his winters iceboating or engaged in daylong skating parties. But summers were bliss. As families settled in at the bathing pavilions lining the shore, our friend would scamper off to meet his pals at a secluded beach nearby. Meant for boys only (for here they frolicked with neither their trunks on nor a care in the world), this sacred spot was known for "an old willow tree with a long, stout rope" they used to swing Tarzan-like into the muddy water below. As if this was not enough, William spent many a lazy afternoon clam and mussel digging; blue claw crabbing; and fishing for flounders, tommy cods, snappers, and mid-sized gamefish called Lafayettes. And just imagine his thrill spotting porpoises in the water's distance! Unheard of today.

That the 20th century would spell the end to this was inconceivable. The shoreline became intolerably polluted—sullying all but the memory of earlier, happier times—and was filled in to accommodate the Grand Central Parkway that passes LaGuardia Airport, whose runways cover what was another seaside pleasure ground, North Beach.

Nearing his 80th year, Coughlan reflected: "Marine life in Flushing Bay has been all but eliminated, the bathing beaches are a thing of the past and the fields of wild cherry trees, wildflowers and a great variety of berries, have long since given way to solid rows of houses."

Corona comprised the northeastern vicinity of Colonial-era Newtown (today's Elmhurst), an expanse abutting the sister town of Flushing, as it does today. As early as the 17th century, the area's founding families first took to the woodlands west of a stretch of land known as "the meadows." With names like Coe, Striker, Fish, Remsen and Rapalye, Lent and Leverich, Berrien and Brinkerhoff, many were to figure prominently in the course of Queens history. The verdant region rose 108 feet above sea level only to give way to open fields, descending to Flushing Creek into a swampy salt meadow. Small foot trails connected their scattered homesteads.

In January 1853, after word came of the Flushing Railroad's pending arrival to this long isolated part of Queens, land speculation initiated a period marked by uncertainty. Targeting the land where noble farmsteads stood in defiance of time, the newly formed West Flushing Land Company planned to create in their stead a suburban residential community to be called West Flushing. In a May issue of the *Flushing Journal*, an anonymous writer—possibly from the West Flushing Land Company—endorsed such a creation, underscoring the striking landscape:

> On visiting the line of the railroad the other day, we found ourselves on that magnificent
> plateau of elevated, rich and nearly level land which has been purchased . . . for village

purposes. . . . On a portion of the property is a small sylvan lake the borders of which are beautifully wooded. This lake is to be enclosed in a park of about four acres. Really, this site for a village is superb.

Less than five years later, the frenzy had abated and the West Flushing Land Company was liquidated, but not before roads and thoroughfares of plank wood and street grids were all laid out. But as lots lingered without any takers, the terrain looked decimated.

Enter Benjamin W. Hitchcock two decades later. Founder of the New York Suburban Building Society, Hitchcock, with Alpheus P. Riker, created the village of Woodside in 1867. Seeing that middle-income earners were the key to West Flushing's viability, Hitchcock came up with a groundbreaking idea called the Homestead System, which availed loans to prospective clients who agreed to employ his firm exclusively to build their homes. Construction costs were to be paid in $10 monthly disbursements, making this the first installment plan ever devised. Its success brought many who otherwise would not have even dreamt of owning their own home to the area. Corona's official founding was now only a matter of time.

It took nearly five decades before much of the rest of Queens followed suit. An integral part of Greater New York by the 1920s, Queens used the city's abundant source of tax revenue to upgrade its infrastructure, luring developers to forge high-end communities like Forest Hills and Jackson Heights, perhaps with Corona's example in mind. Thus considered, Corona is their historical forerunner.

In 1870, however, acting on a concern that the village of West Flushing would be confused with nearby Flushing Village, rival developer and resident Thomas Waite Howard petitioned the US Post Office in Washington, DC, to rename the place "Corona," waxing poetic that it was "the crown of Queens County." It approved the renaming in June 1872 and appointed Howard as Corona's first postmaster.

Boasting a population of 600, adequate roads, and a new post office that bore its name, Corona was also in the thick of a geographically diverse section of the borough. Its secluded northern part offered breathtaking views overlooking Flushing Bay and the pulse of a prosperous town at the heart of the community. The southern part's decreased elevation featured a rustic atmosphere of meadows and wetlands.

Corona (as West Flushing) also enhanced its home borough's reputation as a horseracing mecca, if only briefly. Though Queens was home to Union Course and Centerville, two nationally recognized and well-heeled racetracks, a southern-based consortium called the National Racing Association unveiled a new venue. Called the National (later Fashion) Race Course, it opened in the spring of 1854. Historian Vincent F. Seyfried describes what was a jaw-dropping sight:

> The association . . . assembled an army of about 450 workmen, principally masons and laborers and about 100 bricklayers. The promoters planned to enclose 65 of 141 acres with a brick wall eleven feet high, coped with concrete and broken glass, [where] horses would be trained and tried out. The grandstand with the public stands was 1200 feet in length, 30 feet wide and 32 feet high, the walls 20 inches thick, with buttresses of the same thickness projecting two feet. The roof was constructed so as to give shelter to 2,000 people while the stands and seating beneath accommodated 25,000. The style then popular was "castellated Gothic" with octagon towers and battlements to give the medieval effect. A separate smaller stand was reserved for families and ladies to shelter them from the coarse conduct and cries of the public. Some distance from the track stables were erected for the accommodation of 100 horses.

National Street is what remains of this ambitious enterprise. But there is no need for concern. With the home of the New York Mets, Citi Field, and the Billie Jean King National Tennis Center and Arthur Ashe Stadium present, sport dramas in Corona are far from wanting. Today, Corona continues its legacy of cultural diversity and economic progress that reflects the borough of Queens.

One

FROM WEST FLUSHING
TO CORONA

In June 1854, when the first Flushing Railroad locomotive debuted in western Flushing, many residents hailed it as the catalyst for a better economic future. The excitement they felt was real, yet it was only natural for them to also question how such a future could be realized. One answer was a new village alongside the railroad line itself. A novel idea but not new; those who formed the West Flushing Land Company envisioned this scenario from as early as January 1853. However, the company's later bid to purchase and develop the two centuries-old homesteads that dotted the region was unsuccessful. Displacement was sorely felt. West Flushing (Corona's precursor) was off to an unpromising start.

In the fall of 1869, however, a more coordinated wave of development transpired under the steady gaze of master speculator Benjamin W. Hitchcock. Through an installment plan program he referred to as the Homestead System, Hitchcock, who resided in the area, effectively spread the prospect of home ownership beyond the cash-on-hand wealthy to those with more modest incomes. To keep abreast of projected demand for his homes, in March 1871 Hitchcock erected a 100-foot-wide sawmill east of 102nd Street, running parallel to the railroad. He also positioned his headquarters, a modest one-story building that sported a sign on its roof reading "New York Suburban Building Association" in oversized letters, directly opposite the station to attract the notice of incoming passengers.

While Hitchcock engaged his business acumen, another local developer, Thomas Waite Howard, petitioned the federal government for a separate post office apart from the town of Flushing proper. It was because of this that West Flushing was rechristened Corona in June 1872, taking into account Howard's espousal that the area was the "crown jewel" of Long Island. Similarly, Hitchcock called his development Corona Park, which he meticulously tended to amidst the increased construction in the neighborhood. By 1873, one could say that Corona village was fairly well established. Local industry had taken root, and commercial activity of all kinds flourished. Different immigrant groups—French, Jews, and Italians, in addition to German and Irish—began settling into the area.

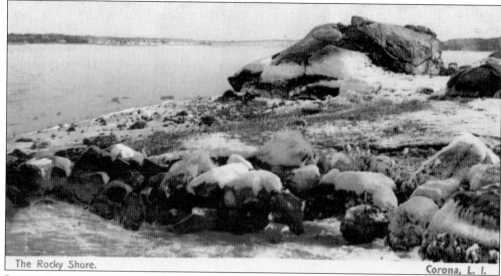

The Rocky Shore. Corona, L. I.

IN THE BEGINNING. The epic story of Corona began millions of years ago when the receding Wisconsin Glaciation, or glacier, created modern-day Long Island, of which Queens County is a part. Large boulders such as these found along the Corona shoreline generally remain where they dropped from the melting ice. An exception to this is seen on the North Shore, where boulders have dropped to the beach as the sea has eroded the cliffs. Most of Corona sits 50 to 70 feet above sea level, with the highest point being 108 feet, at Astoria Boulevard and 105th Street.

THE LEVERICH WOODS. To the indigenous people (the Matinecock) and early European settlers, this is how Corona appeared hundreds of years ago. A thickly forested landscape made travelling by foot or even horse and buggy a difficult venture. The first settler who came to the area that would become Corona was Robert Coe in 1655. The woods were thickest near present-day Junction Boulevard. Here is the Leverich Woods, situated behind Union Church, roughly near 100th Street and Forty-first Avenue.

QUEENS IN REVOLUTIONARY TIMES. This rare map from *A Survey of New York* by J.F.W. Des Barres is an original finished manuscript never published at the time showing Flushing and Newtown (now Elmhurst and Corona) and the vicinity, including Whitestone and College Point. This incredible find is one of four maps discovered by researcher and collector Andrew Adamson in the United Kingdom. They are more than 200 years old. (HeritageCharts.com.)

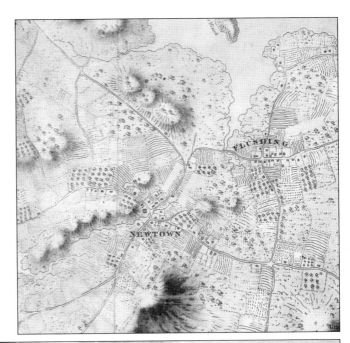

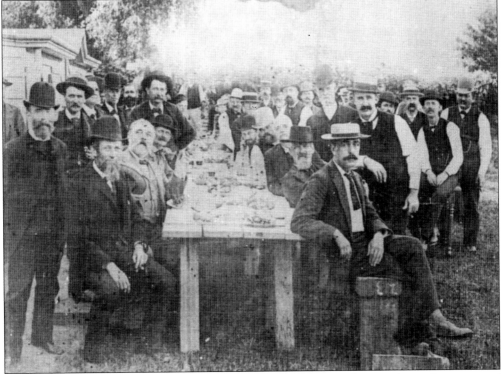

VILLAGE TRUSTEES. The village trustees of Flushing took their annual outing during the summer of 1887 to one of the many pleasure grounds near Flushing Bay to pose for this group photograph. For years, Corona was the child of both Flushing and Newtown, always benefiting and growing from the nurturing of these two communities. The trustees were responsible for handling everything from the naming of streets and deciding property lines to sanitation and the public's well-being.

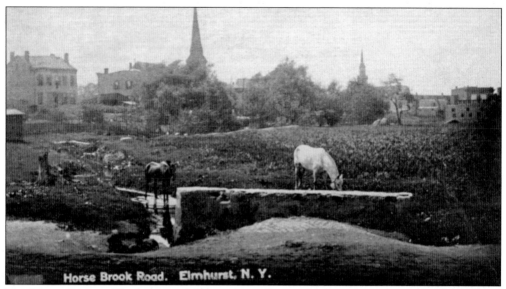

Horse Brook Road. Elmhurst, N. Y.

THE HORSE BROOK. The history of Corona began here. The Horse Brook, as it was called, was a tributary from the Flushing River on the most southwestern corner of the Flushing Meadows. The people of Newtown and those traveling from the east toward the city used the stream to water their horses.

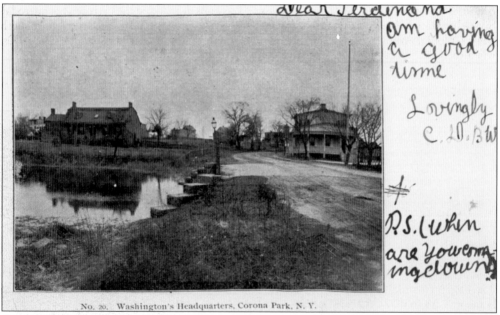

No. 20. Washington's Headquarters, Corona Park, N. Y.

COE'S MILL. On this property by the Horse Brook stood the earliest home built in Corona, erected in the area that would become known in 1887 as Corona Park. Constructed by Robert Coe in 1655, the home on the left stood at what are now Colonial Avenue and the Long Island Expressway. Using water from the brook, the Coe family erected the first gristmill located near the village of Newtown. On the right is William Geyer's Hotel. The view is looking north up Colonial Avenue. The caption on this postcard reads, "Washington's Headquarters, Corona Park, N.Y." Although Pres. George Washington did visit Flushing in October 1789, whether he ever stayed on the Coe property is perhaps the stuff of rumor and legend.

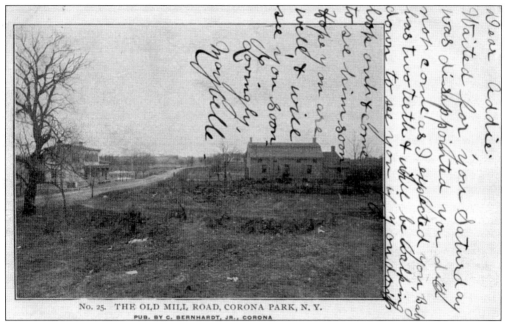

No. 25. THE OLD MILL ROAD, CORONA PARK, N.Y.
PUB. BY C. BERNHARDT, JR., CORONA

COE HOUSE AND MILL ROAD. The early settlers of Newtown and Maspeth laid out the Old Mill Road in 1656 in order to gain access to the gristmill. The road was broken up almost three centuries later when the Long Island Expressway was built. It followed the path of what are today Sixty-third Road, Apex Place, Sixty-second Drive, and Colonial Avenue. This view looks south down Colonial Avenue (the Old Mill Road). It is amazing that this view lasted until the 1930s, when the Coe property and Horse Brook were paved over for the coming of the expressway.

RAPELJE HOME. The Coe property later became the home of Daniel Rapelje (also spelled Rapalye). The Dutch Colonial home was originally constructed of brick and imported wood from Holland. Rapelje settled here in 1793, buying the surrounding 170 acres. He died here in April 1829.

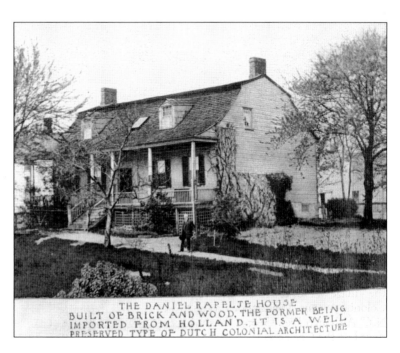

THE DANIEL RAPELJE HOUSE BUILT OF BRICK AND WOOD, THE FORMER BEING IMPORTED FROM HOLLAND. IT IS A WELL PRESERVED TYPE OF DUTCH COLONIAL ARCHITECTURE

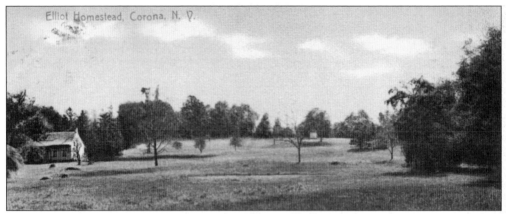

ELLIOT HOMESTEAD. Pictured here is the property belonging to family members George and John Elliot, who acquired it in 1853. Another early inhabitant named Leverich originally owned the land and homestead. Sharing the property on the left stands the Berrien-Rapalye house. Today, this open meadow is near the crossroad of Thirty-eighth Avenue and 114th Street. After John Berrien died here in 1711, the home and property passed to the husband of Berrien's sister Agnes, named Joris Rapalye. The property was sold in the days when the Corona area was still part of Newtown. Known as "the small house," it was covered with cypress and cedar shingles and burned down in 1906.

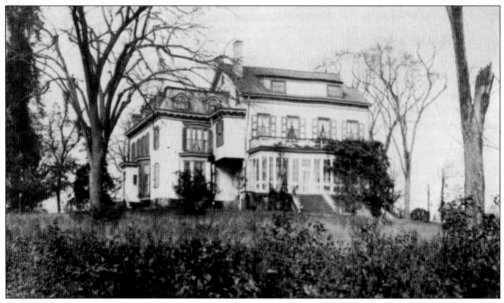

ELLIOT MANOR. Built by the Leverich family in 1666, this beautiful mansion was rebuilt and expanded upon over a 200-year period. Rev. William Leverich came to the area in 1662 after working as a preacher in Huntington, Long Island. At that time, even Newtown was known by a different name, Middleburg. Originally from England and educated at Cambridge in 1625, Leverich died in 1677, with the property going to his sons Caleb and Eleazer. Col. Edward Leverich, the last member of the family to own the homestead known as Fair View, sold it to the Hendrickson family in 1820. The estate was later purchased by the Elliot family in 1853. It was enlarged in 1860 and renamed "the great house." It was sold in 1910 to developers. The home was situated near 115th Street between Thirty-eighth and Thirty-ninth Avenues, the latter formerly known as Hendrickson's Lane.

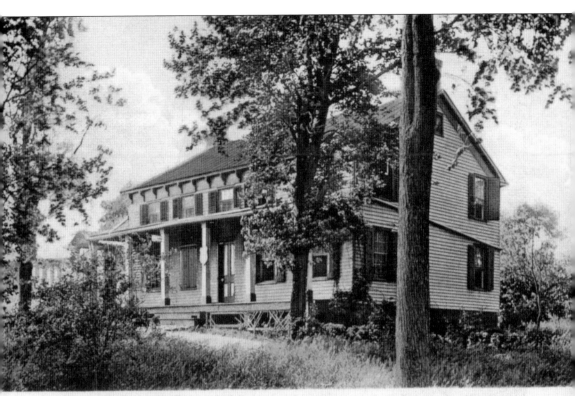

The Van Wickel Homestead, Built A.D. 1765, Corona, L. I., N. Y.

THE VAN WICKEL HOMESTEAD. One of the earliest properties to be built in the Corona area was the home of Daniel Van Wickel, in 1765. It was located on the north side of Corona Avenue opposite present-day Ninety-eighth Street and consisted of 20 acres. It was demolished in April 1916. (Queens Borough Public Library, Archives, Post Card Collection.)

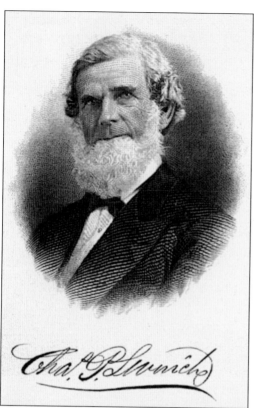

A DISTINGUISHED GENTLEMEN. This woodcut portrait is possibly the only surviving likeness of Charles P. Leverich. One of the founding fathers of the area that would become Corona, Leverich was born in 1809, the brother of Henry S. Leverich. He would become president of the Bank of New York and a prominent benefactor of Corona. He donated the land for Union Evangelical Church and even taught Sunday school. He died in 1876 and was buried in the old Presbyterian cemetery located on Queens Boulevard.

CHARLES P. LEVERICH HOMESTEAD. In 1841, Charles P. Leverich came to Corona, purchased 16 acres of land on the west side of Junction Avenue (Boulevard), and later built a homestead near Thirty-fourth Avenue and Ninety-fourth Street. The three-story house and property, stables, and a greenhouse were sold for development in 1928.

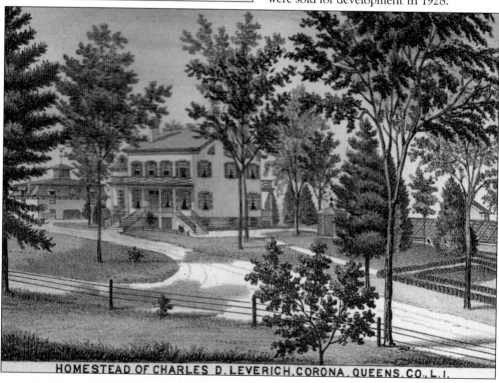

HOMESTEAD OF CHARLES D. LEVERICH, CORONA, QUEENS, CO., L.I.

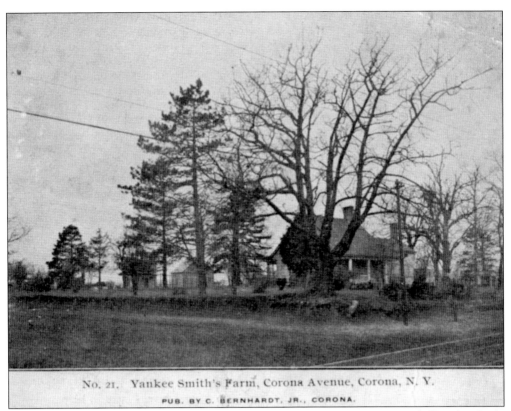

No. 21. Yankee Smith's Farm, Corona Avenue, Corona, N. Y.

PUB. BY C. BERNHARDT, JR., CORONA.

YANKEE SMITH'S FARM. Another large estate in old Corona, the Smith farm, was settled by Rhinebeck, New York, native John H. Smith in 1837 along Corona Avenue in the section that would become known as Corona Heights. Built upon a wedge-shaped piece of land on the south side of Corona Avenue between Fifty-Third and Fifty-Seventh Avenues, it featured a small lake, or kettle pond. Smith named the property—featuring his Dutch-style farmhouse—Shady Lake Farm. In the summer, people flocked to the area for picnics, and in the winter, Smith cut ice from the lake and sold it in Flushing. Because he was from northern New York State, people in Corona called him "Yankee Smith." (Queens Borough Public Library, Archives, Post Card Collection.)

GEORGE I. RAPELYE HOUSE. Born in Nova Scotia in 1787, George I. Rapelye came to Corona with his father in 1792. In 1814, Rapelye married Lydia Burroughs. This version of the homestead was built in 1852 and inhabited until 1875. After various successive owners, the home, formerly located at 60 Corona Avenue, today 99-32 Corona Avenue at the southwest corner of 102nd Street, was renovated in 1933 and reopened to the public as the New Cottage Inn in November 1933. (Queens Borough Public Library, Archives, Eugene L. Armbruster Photographs.)

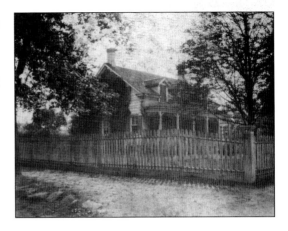

19

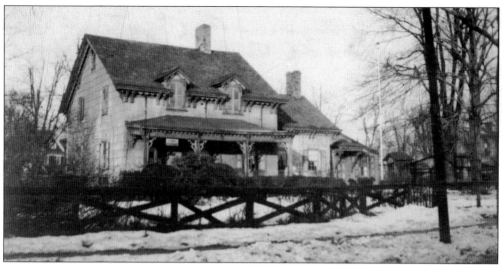

THE BURROUGHS HOUSE. On the northeast corner of Corona Avenue and 102nd Street stood the home of the Burroughs family, who settled in Corona before the American Revolution. It was John Burroughs (sometimes spelled Burroughes) who first came to the area in the 1640s and was the town clerk of Newtown for 11 years. Descendant George W. Burroughs died here in 1891 and his daughter, Mrs. Isaac L. Moe, was the last owner of the property, which was demolished in 1930. (Queens Borough Public Library, Archives, Eugene L. Armbruster Photographs.)

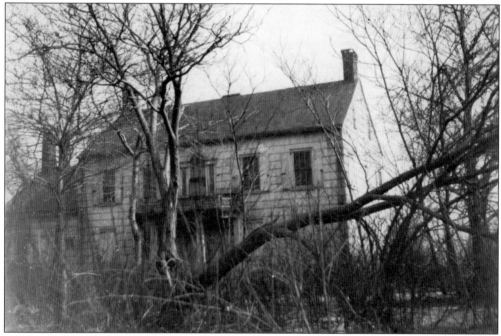

BENJAMIN MOORE HOUSE. The home of Benjamin Moore was built around 1700 and stood on Junction Boulevard east of Ninety-sixth Street. It originally belonged to the Penfold family for generations before Moore took it over in 1852. The home remained in the Moore family for many years, with Moore's wife living here until 1873. William Card became the last owner, living here until 1923, the year the structure was demolished. (Queens Borough Public Library, Archives, Eugene L. Armbruster Photographs.)

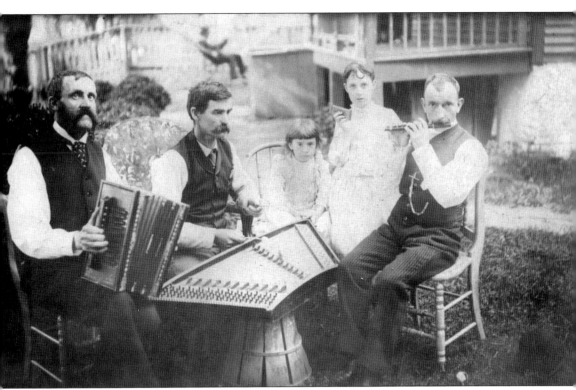

PASSING THE TIME. In this charming photograph, unidentified Corona men are enjoying an afternoon off while playing their instruments. Music was an important part of the culture of the many Italian, German, and Irish immigrants who lived in Corona. (Queens Historical Society.)

STRONG'S CAUSEWAY. The only link between Newtown and Flushing at the southern end of the meadows where the Flushing River terminates, or "head of the vleigh," was Strong's Causeway, built by the Strong family in 1801. The North Hempstead Turnpike Company built a small bridge, only 15 feet wide, that same year. George Mayer's Spring Hill Clubhouse can be seen on the right behind the thicket of trees. (Queens Borough Public Library, Archives, Borough President of Queens Collection.)

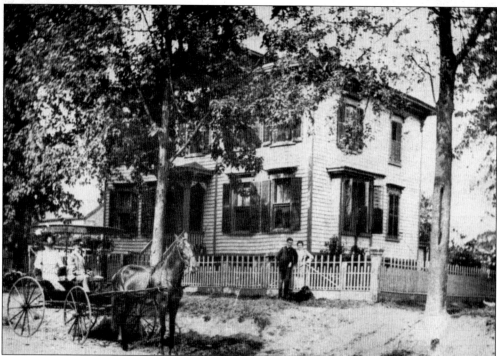

W.C. HARVEY HOUSE. The W.C. Harvey House was located on the northeast corner of 108th Street and Forty-second Street. The two-story mansion featured a private tennis court in the rear of the property. The Harvey family and home are shown here in 1900.

THE WOMEN OF THE HOUSE.
This is a rare and unpublished
photograph from the mid-1880s
of the women of the Preston
family posing in front of their
home along Corona Avenue.

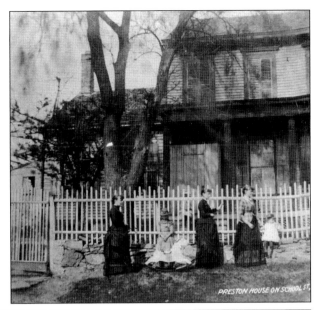

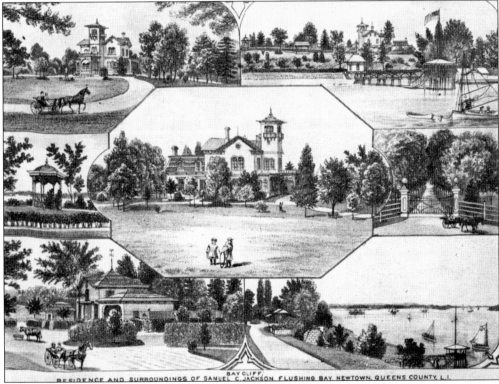

SAMUEL C. JACKSON ESTATE. Overlooking the Flushing Bay at the split between Northern and Astoria Boulevards stood the grand estate of Samuel C. Jackson. Jackson was the son of assemblyman and judge Thomas B. Jackson, who once lived at the old Fish's Mill along what became known as Jackson Creek (presently the Grand Central Parkway at Ninety-fourth Street). The estate was built from a fortune that Jackson made in the mercantile and manufacturing business. (Munsell's *History of Queens County*.)

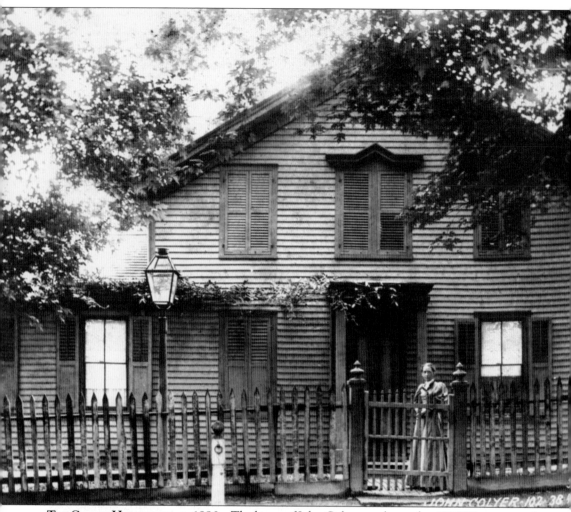

THE COLYER HOMESTEAD, C. 1890s. The home of John Colyer was located at 102-38 Forty-seventh Avenue. Built in the 1700s, the two-story home stood on a large 200-foot property. The last owner was Emma Main, who lived there until developers bought it in 1934. This remarkable photograph is published here for the first time. (Queens Topographical Bureau.)

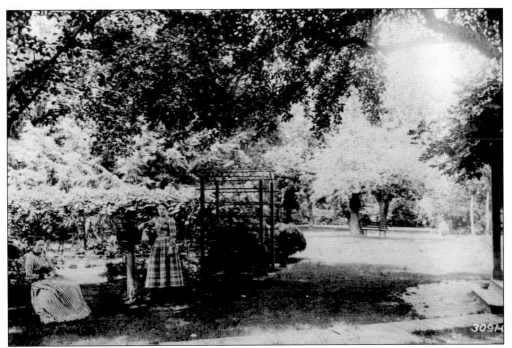

THE COLYER FAMILY. The women of the John Colyer family are seen enjoying an afternoon in their garden, which featured grapevines and many types of fruit trees. (Queens Topographical Bureau.)

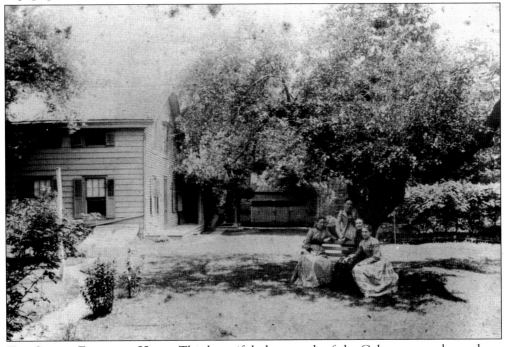

THE COLYER FAMILY AT HOME. This beautiful photograph of the Colyer women beneath an apple tree in the rear of their home serves as an everlasting reminder of the bygone days of West Flushing and old Corona. (Queens Topographical Bureau.)

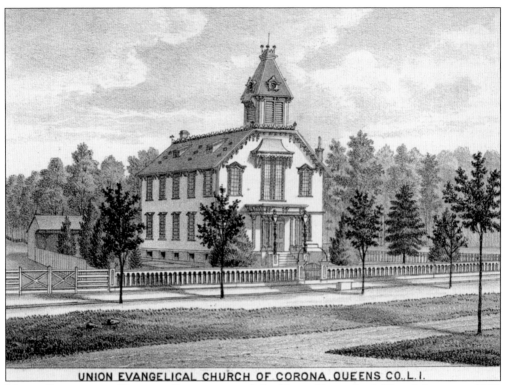

UNION EVANGELICAL CHURCH OF CORONA, QUEENS CO., L.I.

Union Evangelical Church. Construction of the Union Evangelical Church began in 1869, and the first Sunday school was held on April 24, 1870. On June 5 of that year, the first service was held. In May 1873, the church was formally organized as Union Church. Charles P. Leverich donated a building that was used as an extension for Sunday school in 1889. (Munsell's *History of Queens County*.)

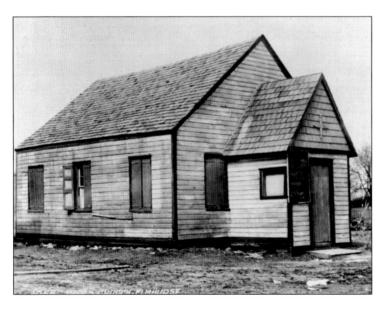

A Humble Church. The St. Marks African Methodist Episcopal Church was located on the northeast corner of Corona Avenue (then known as Union Avenue) and Ninetieth Street. Built in the late 1800s, it was headed by the Reverend James Stanton of Brooklyn and was in use until the 1930s. It was torn down before the decade was over. (Queens Topographical Bureau.)

BOCHTON, QUEENS. One of the strangest incidents in Corona's history was when the area was briefly called Bochton. The name was self applied by William Boch, who operated a French china and porcelain plant, one of the first prominent factories built in Corona. Born in Prussia in 1797, Boch operated a plant with his sons William Jr., Nicholas, Anthony, and Francis beginning in 1850. In 1857, it was purchased by Thomas C. Smith and renamed the Union Porcelain Works. In June 1868, the Bochs moved their operations to Corona. The factory was an E-shaped building bounded by Thirty-eighth and Thirty-ninth Avenues and 104th and 108th Streets. Boch took out an advertisement that year in Curtin's *Directory of Long Island* in which he renamed Corona Bochton. On February 12, 1872, William Boch died, and his sons continued his business successfully. On May 4, 1875, fire destroyed most of the factory, a blow from which the Bochs never recovered. In 1877, William Maguire began a straw business in what remained of the burned-out facility.

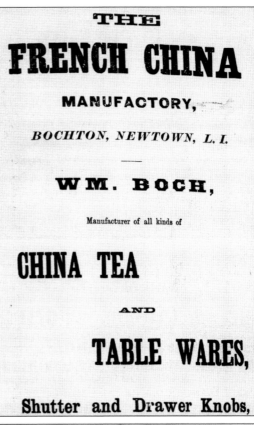

THE

FRENCH CHINA

MANUFACTORY,

BOCHTON, NEWTOWN, L. I.

WM. BOCH,

Manufacturer of all kinds of

CHINA TEA

AND

TABLE WARES,

Shutter and Drawer Knobs,

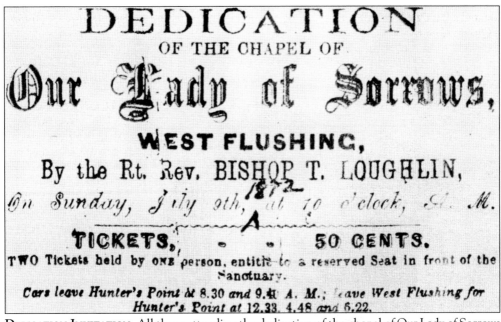

DEDICATION INVITATION. All those attending the dedication of the chapel of Our Lady of Sorrows received this special invitation. It was held on Sunday, July 9, 1872, at 10:00 a.m. and was conducted by the Reverend Bishop T. Loughlin. Tickets cost 50¢. (Vincent F. Seyfried Collection.)

DEVELOPMENT ADVERTISEMENT. This period advertisement dated June 1853 by Abraham Beale promoted subdivisions out of the Hendrickson and Burroughs farmsteads in West Flushing. Note that there was a move to set up a village association similar to that of Morrisania in the Bronx along the Harlem Railroad line earlier. This was meant to guarantee investors substantial profits. The promotional would go on to highlight the advantages of the area, specifically the varying widths of the streets and a splendid park with a "romantic lake" as its centerpiece to be gifted by the developers—all for a modest sum.

THE STAGECOACH, 1830. The Flushing, Newtown, and New York Stage ran along Northern Boulevard at the intersection of Main Street, departing Benjamin Lowerre's Flushing Hotel at 7:00 a.m. and arriving at John Dodge's Hotel in Newtown. The stage was a popular method of travel in the days before the coming of the trolley. This advertisement appeared in the *Long Island Farmer*.

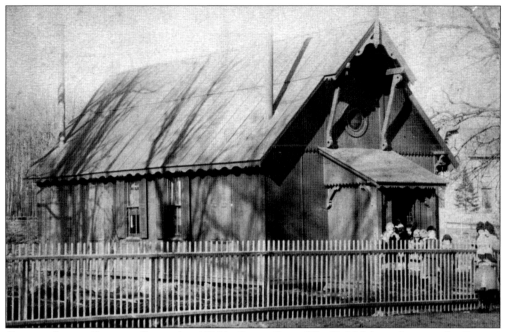

CORONA SELECT SCHOOL. Opened in 1883 by Jennie Lee of Sheffield, Massachusetts, the Corona Select School was a private primary school located on Forty-third Avenue between the Union Church and the railroad depot. The schoolhouse, described in the April 16, 1885, issue of the *Newtown Register* as a "very tasty and pretty building," was manufactured by the Corona-based American Patent Portable House Manufacturing Company. (Queens Borough Public Library, Archives, Irene S. Devan Collection.)

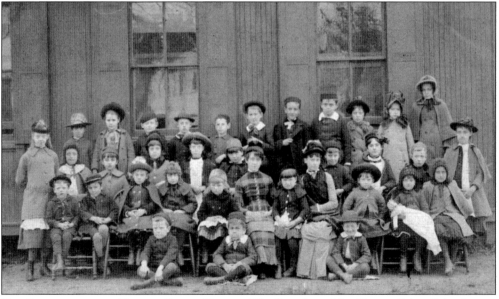

THE STUDENTS OF THE CORONA SELECT SCHOOL. The first class of the Corona Select School poses for a group portrait in 1883. The school was phased out in 1893. In 1900, the schoolhouse became the Salem Swedish Lutheran Church. Jennie Lee went on to become a teacher at PS 16, and she passed away in 1935. (Queens Borough Public Library, Archives, Irene S. Devan Collection.)

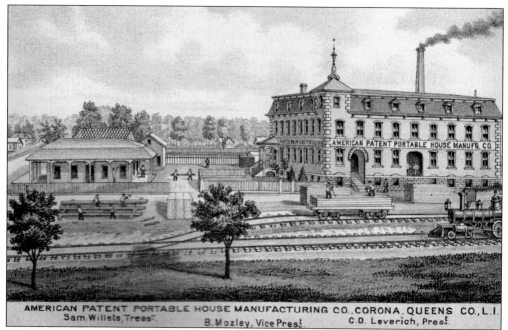

AMERICAN PATENT PORTABLE HOUSE MANUFACTURING CO., CORONA, QUEENS CO., L.I.
Sam. Willets, Treas. B. Mozley, Vice Pres. C.D. Leverich, Pres.

AMERICAN PATENT PORTABLE HOUSE MANUFACTURING COMPANY. Perhaps one of the biggest industries to ever exist in Corona was the American Patent Portable House Manufacturing Company. Established in 1880, Charles D. Leverich became its president, B. Mozley the vice president, and Samuel Willets the treasurer. The company, situated along the line of the Long Island Rail Road (LIRR) east of 102nd Street, produced prefabricated parts for houses, which could be assembled in just a matter of hours. In April 1885, the company received a contract to produce prefabricated houses for men working along the Panama Railroad. By 1890, the company was producing homes and shipping them to Canada, Mexico, and Brazil. It went out of business in 1904. (Munsell's *History of Queens County*.)

SANFORD HOME. Built in 1870 by Edward E. Sanford, this prime example of a 19th-century frame home built in the Italianate style is still standing at 102-45 Forty-seventh Avenue. The home, today a historical landmark, was inherited by Sanford's daughter Irene Devan. The photographs of the Corona Select School were part of her collection. Sanford's other daughters, who at one time or another resided here, were Grace and Edith. (Queens Borough Public Library, Archives, Borough President of Queens Collection.)

Public Notice for Corona's Incorporation. As the law required, this public notice dated May 17, 1893, was issued to inform residents of an election over Corona's proposed incorporation. This would have allowed Corona to run its own administrative affairs, a mark of true political autonomy.

Old Meets New. This view looking north up Colonial Avenue at the Coe property in 1925 shows the newly developed homes of the growing Corona community being constructed on the ancient homestead. (Queens Borough Public Library, Archives, Eugene L. Armbruster Photographs.)

CITY'S SMALLEST SCHOOLHOUSE DOOMED.

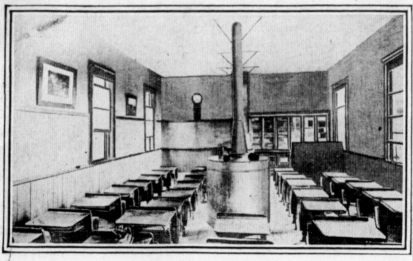

Interior of School No. 10, Corona.

WITHIN the boundaries of New York City is a school building that would grace almost any backwoods farm district, so primitive is it and so like those little school houses of a past generation. Flushing road, Corona, in Queens Borough, is the site of this structure, which has, by the way, been doing duty as an educational institution for over thirty years. A magnificent new building on modern lines is now in process of erection in Corona, and the little school house will soon be closed down permanently. The school house is a survival of the days when that part of Long Island was a rural district, far removed from the metropolis, with its educational demands and ideals. The farmers of the section decided they must have a district school for their children to attend during the winter months, when there were no chores on the farms to keep them occupied. So they formed a district, as required by law, which was called the Bowery Bay District, and taxed themselves for funds with which to build a school house. It was a primitive affair, constructed of timbers hewn from the trees at the top of the hill on the turnpike that led from the village of Astoria to Flushing, the clearing thus made being used for the site.

It has but one schoolroom, the dimensions of which are 19x28 feet. In the center is a great stove. Six rows of desks—fifty-two in all, graduating in size—run from front to rear. At the right, facing the teacher's desk, which is the sort used by schoolmarms half a century ago and bears every evidence of its age, are diminutive desks used by beginners, or the A B C class. Each succeeding row has desks of a larger size, until at the extreme left there are desks suited to boys and girls of 8 to 10 years. There are six classes in this one room, all of which are taught by the same teacher. The school not only bears the distinction of being the smallest school in Queens,

but it is the only school where but one teacher is employed to teach all the branches in the curriculum. When the school was founded the three most substantial men of the Bowery Bay District were chosen school trustees—Isaac Rapelyea, Garret Kowenhoven and William Hanson. They opened the school in the fall of 1879.

Miss Emma Fagan was appointed as teacher, and she served the school for thirty years, through most of its career, having been pensioned by the Board of Education only last September. At present there are thirty-four pupils registered at the school, representing five nationalities — Americans, Germans, Poles, Bohemians and Italians. They are divided into six classes, from 1A grade to 4B, and they are taught, in addition to arithmetic, geography, history and the other fundamentals, drawing, singing, music and sewing. The interior of the little school room about to be abandoned gives an interesting illustration of the change in school methods that has taken place in the last half century. On the walls is a map of the United States and showing but few of the states west of the Mississippi, while in close proximity is a map of New York State of to-day. In a corner, suspended on a tripod, is the inevitable globe, without which no schoolroom was complete in the old days. It has seen thirty-one years of service. One corner of the room is dedicated to the use of a small organ, the front of which is draped with a big American flag. The organ is of ancient make, but the flag is a recently acquired emblem, supplied by the City of New York to mark its schoolhouses.

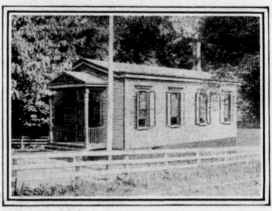

Exterior View of Corona's Miniature School.

THE CITY'S SMALLEST SCHOOLHOUSE. The one-room schoolhouse of PS 10 was the topic of a feature article in the *Brooklyn Daily Eagle* dated June 28, 1910. Constructed in 1879, the wooden building, located in a poor section known as Frogtown at the southwest corner of Astoria Boulevard and Ninetieth Street, was heated by a potbellied stove and contained 52 desks, all within a space measuring 19 by 28 feet. Emma Fagan was the teacher here for more than three decades. The schoolhouse was closed in 1925, and the site today is a park known as One Room Schoolhouse Park. (*Brooklyn Daily Eagle*.)

THE FINAL DAYS OF THE COE HOUSE. Captured in a photograph from October 27, 1926, the Coe homestead sits abandoned in its final days before development of Horace Harding Boulevard (later the Long Island Expressway) would bring about its destruction in 1930. The home had stood on this spot for 275 years. (Queens Borough Public Library, Archives, Borough President of Queens Collection.)

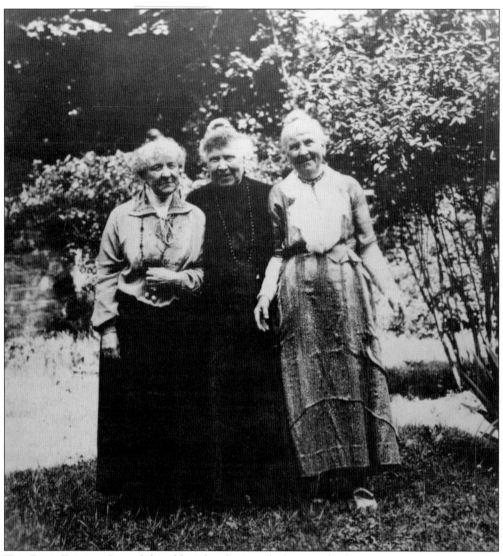

THE PECK FAMILY. One of the oldest families in Flushing and Newtown was the Peck family. Beginning with Jonathan Richard Peck, who settled in Flushing in 1790, the family enjoyed success in farming, local politics, business, and as members of the clergy. After the passing of Jonathan in April 1822 at the age of 54, he was followed by a long line of family members who proved to be persons of sagacity and enterprise. Dr. William Jay Peck was minister of the Union Church, and Isaac Peck operated one of the first shipyards along Flushing Creek. Curtis and Elijah Peck operated the first steamboat service to Manhattan. Seen here are some of the last members of the Peck family in Corona. From left to right are Elizabeth, Emma (born 1854), and Florence (born 1870). Today, Peck Avenue continues their legacy. (Queens Topographical Bureau.)

Two

THE RAILROAD COMES TO TOWN

The Flushing Railroad operated the first train line to Corona on June 26, 1854, which coincided with the opening of the National Race Course. Named the West Flushing Station, it was first located on the south side of National Avenue (Street). Later, it was relocated to what is today 108th Street and Forty-fourth Avenue. The fare was 25¢. After the racecourse closed in 1869, the Flushing & North Side Rail Road came to Corona, building a depot in September 1872.

The railroad craze had officially begun, with many competing lines being started by wealthy entrepreneurs. The president of the Long Island Rail Road (LIRR), Oliver Charlick, started a competing line, Newtown & Flushing Rail Road. Known as the "White Line" because of its gleaming white train cars, it ran for 2.5 years, from November 1873 to April 1876. Branching from the main LIRR line just south of the old Winfield Junction east of Woodside, it ran roughly parallel to the Flushing & Northside, now part of the LIRR's Port Washington branch. The line made stops at Winfield (Woodside), Newtown (Elmhurst), Corona Park (near 111st Street and the park), and terminated in Flushing on the west side of Main Street and Forty-first Road. In 1876, rubber baron Conrad Poppenhusen of College Point purchased the LIRR and closed down the White Line.

On December 9, 1880, the Flushing & North Side Rail Road station burned down. The former Corona Park depot from the White Line, abandoned now for four years, was moved to the site as a replacement around 1890 and was itself torn down around September 1894. Eventually, the Flushing & North Side Rail Road was absorbed by the LIRR.

Yet another station was built, lasting until 1930. This line later evolved into the LIRR's Port Washington branch, which remains to this day.

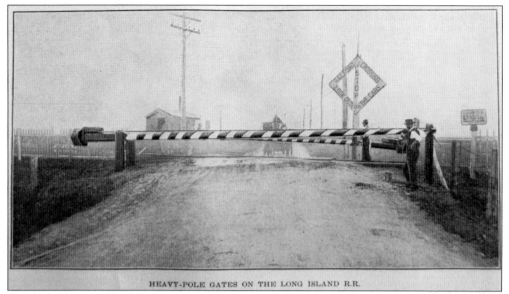

CROSSING GATES. As part of the Long Island Rail Road's safety program, heavy pole gates were installed at all grade crossings. Accompanying the gates were the diamond-shaped signs that read, "Stop! Railroad Crossing, Look Out For The Cars." This photograph of a crossing, published almost 90 years ago, is on the Corona line of the LIRR at a point just outside Flushing Meadows.

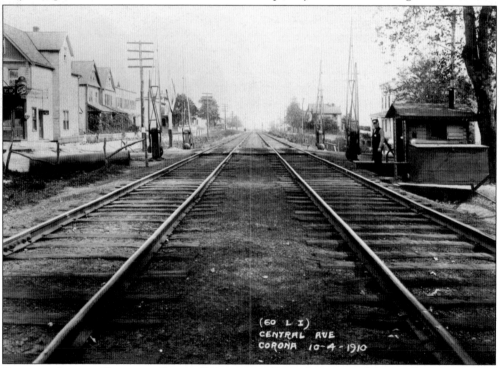

CENTRAL AVENUE CROSSING. Originally known as Central Avenue, this view looks east down the tracks at the grade crossing at what is today 108th Street on October 4, 1910. The track bed was designated as Rail Road Avenue. On the right stands the gatekeeper, who would raise and lower the crossing gates. On the far left is the Sycamore Café. (Archive of R.L. Presbrey.)

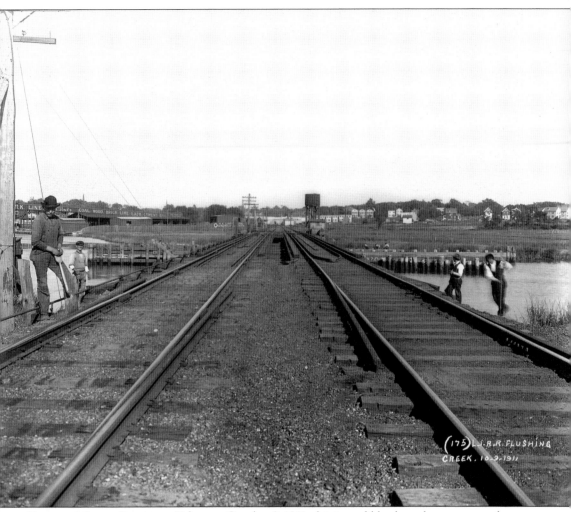

FLUSHING CREEK CROSSING. Taken on October 9, 1911, this incredible glass-plate exposure shows workmen along the Port Washington branch of the LIRR on the approach to Corona from Flushing. It was here that the Whitestone branch (formerly of the Flushing & North Side Rail Road) merged with the Port Washington line. In the left background is the warehouse of H.K. Lines, sellers of coal, wood, brick, cement, lime, and lath.

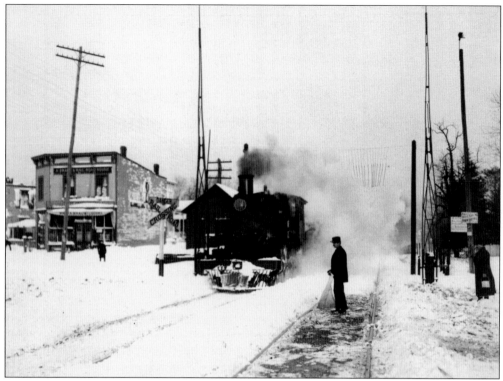

THE DAYS OF STEAM. Roaring into Corona on a snowy winter day in 1901 is a steam locomotive moving west toward Manhattan's Pennsylvania Station.

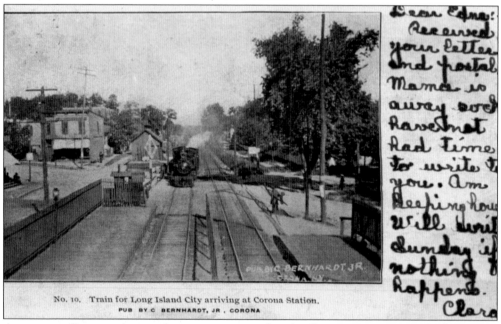

No. 10. Train for Long Island City arriving at Corona Station.
PUB BY C. BERNHARDT, JR., CORONA

ARRIVAL AT CORONA. A steam locomotive approaches the Corona station in 1905. This station was the fourth to be built. Made out of brick unlike its three wooden predecessors, the station was built and opened for operation in 1894.

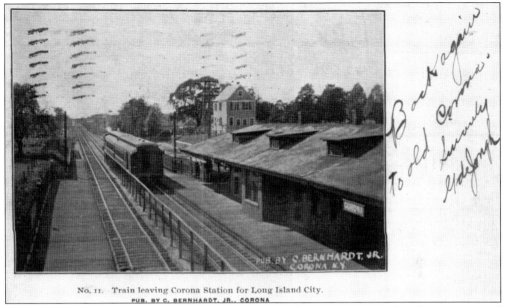

No. 11. Train leaving Corona Station for Long Island City.
PUB. BY C. BERNHARDT. JR., CORONA

DEPARTURE AT CORONA. This locomotive is departing the Corona station, heading west toward Long Island City. The inscription on the right side of the postcard, dated 1905, reads, "Back again to old Corona." An interesting thing to note is the single home behind the station surrounded by a pastoral backdrop.

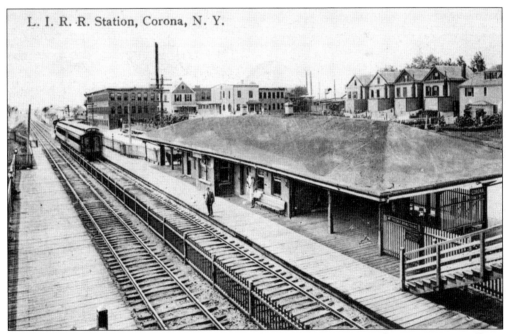

L. I. R ·R. Station, Corona, N. Y.

DEVELOPMENT. This postcard view from exactly the same perspective as the previous one offers a dramatically different view. It is now 1912, and several homes have been built behind the station. Also standing in what was open space shown in the previous photograph are the two three-story brick studios of the Louis Comfort Tiffany Glassworks.

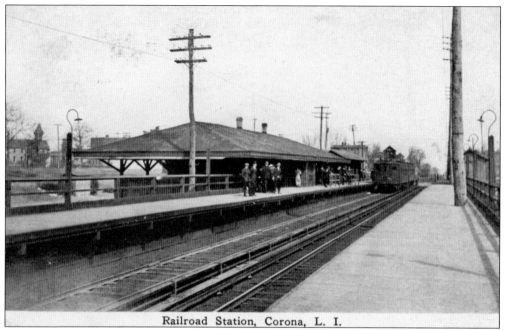

Railroad Station, Corona, L. I.

ELECTRIFICATION. The LIRR electrified its tracks and officially phased out steam in 1913. The Corona station is seen here after modification for electric trains with the installation of a third rail that housed the electrical current. To avoid disaster and loss of human life, the tracks were depressed more than six feet to prevent anyone from being fatally electrocuted.

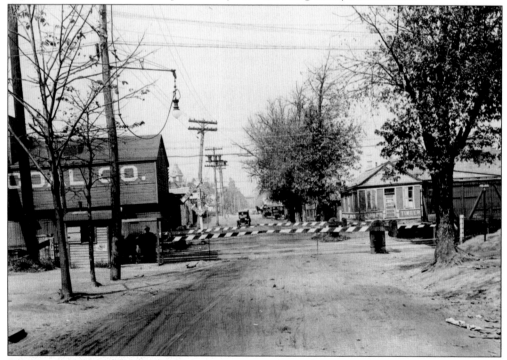

WAY STREET CROSSING. The grade crossing at Way Street (now 102nd Street) is shown here on September 4, 1927. The Corona Coal Company silo is at left. (Vincent F. Seyfried Collection.)

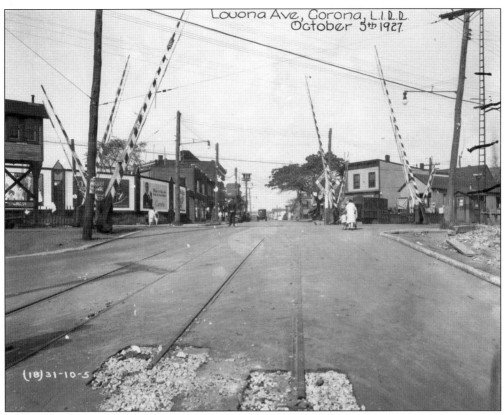

(18)31-10-5

LOUONA AVENUE CROSSING. Pictured here is the grade crossing at Louona Avenue (today National Avenue) on October 5, 1927, looking north toward Roosevelt Avenue. In the center stands a police crossing guard. (Queens Borough Public Library, Archives, Public Service Commission Photographs.)

END OF CORONA STATION. This image of the Corona station is one of its last known photographs of the stop. Deemed as too antiquated, it was torn down and replaced with a more modern edifice in 1930. (Queens Borough Public Library, Archives, Frederick J. Weber Photographs.)

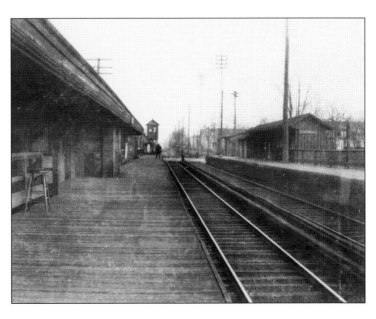

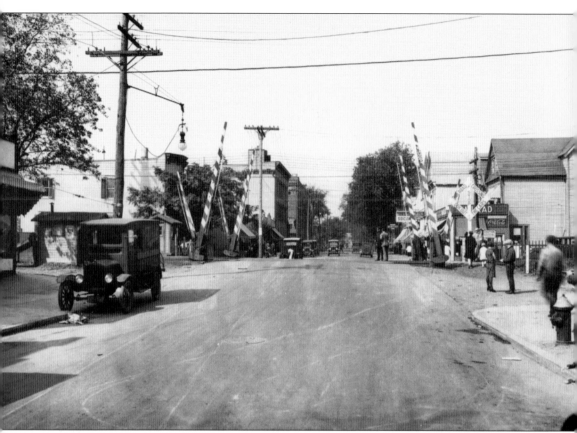

GRADE CROSSING AT 104TH STREET. This view looks north up 104th Street from Forty-fifth Avenue in 1928. The LIRR was instrumental in helping Corona grow from a remote outpost to a thriving community. By the late 1920s, Corona was one of the largest up-and-coming neighborhoods in Queens.

Three

THE BIRTH OF CORONA VILLAGE

Corona had moved on from its origin as West Flushing and became a well-established village in 1873. It had been officially recognized by the post office (since it had more than the 600 people per square mile requirement). F.W. Beers and Company for the first time included Corona in its atlas of Long Island and New York City. By 1875, Corona had a population of 885 people. Within months, a firehouse, churches, stores, saloons, and meeting halls were established. Industry also sprang up overnight, the first being a porcelain works, followed by the Long Island Straw Works, and ultimately the American Patent Portable House Moving Company. The railroad brought more and more people from the west (Manhattan) and the east (Long Island) to Corona each month. For the town's creator, real estate agent Benjamin W. Hitchcock, business was booming. The first businesses began to appear, owned by loyal Corona natives and transplants whose names have been long since been forgotten. These entrepreneurial individuals included William Deigman the milk man, Henry Tieman the barber, Uriah T. Chamberlain the undertaker, A. Stiehl the baker, and Fred Stokes, William H. Phillips, and Alex Dujat the town blacksmiths. The modern-day amenities of telephones, electricity, and gas would not come to Corona until the 1890s. It was in May 1891 that undertaker Uriah T. Chamberlain had installed Corona's first telephone in his home. Operated by the New York & New Jersey Telephone Company, the first phone number in Corona was Williamsburgh 766B. In May 1894, fresh water reached the homes of Corona via pipes laid down by the Citizens Water Supply Company. And everyone gathered on the night of June 14, 1895, when a switch was flipped and electric light entered the homes and businesses of Corona. The streets became lit by gas on August 7 of that year when the Newtown Gas Company finally installed pipes throughout the village. The first newspapers were the *Long Islander Endeavor*, published by the Reverend William J. Peck of the Union Church in 1886, and the *Corona Courier* in 1896. By the time of the consolidation of Queens with Greater New York City in 1898, Corona had 2,500 residents. In two decades, that would increase to more than 40,000, as Corona's popularity and population grew with each passing decade.

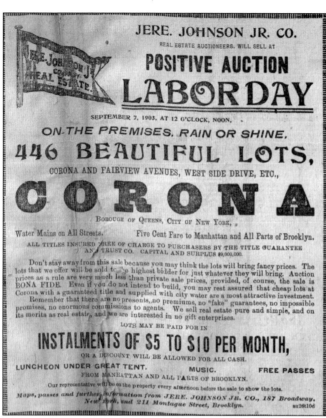

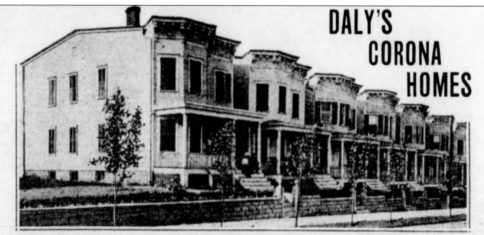

DALY'S CORONA HOMES. This small placement advertisement in the *Brooklyn Daily Eagle* promotes a developer named Thomas Daly and the new homes he was building near Jackson Avenue (Northern Boulevard) and Benjamin Street (101st Street) in 1912. (*Brooklyn Daily Eagle.*)

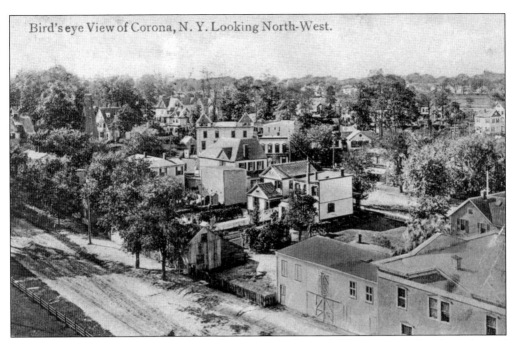

Bird's eye View of Corona, N. Y. Looking North-West.

A BIRD'S-EYE VIEW, 1900. This view looking out upon beautiful Corona was taken from the roof of PS 16 looking northwest across Forty-first Avenue toward National Street. Linden Lake Park is in the lower left-hand corner, at center is Warwick Hall, and on the right is Roosevelt Avenue.

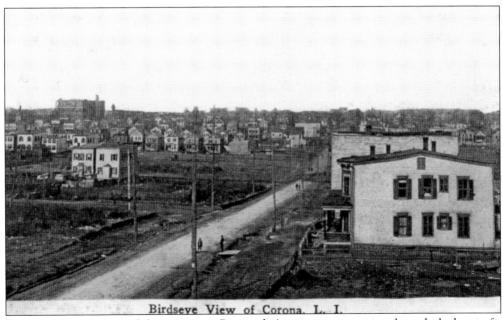

Birdseye View of Corona. L. I.

LOOKING EAST. At around the same time, Roosevelt Avenue is seen cutting through the heart of a developing community. Note the absence of the elevated Interboro Rapid Transit (IRT) line in this postcard image from 1900. (Queens Borough Public Library, Archives, Post Card Collection.)

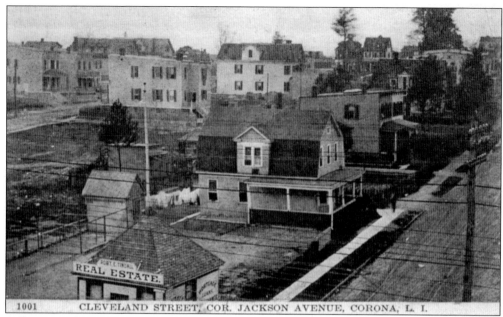

A GROWING COMMUNITY. Corona increased in physical size and population due to aggressive real estate marketing. Here, at the corner of Cleveland Street (106th Street) and Jackson Avenue, stood the Robert E. Tindall Real Estate office.

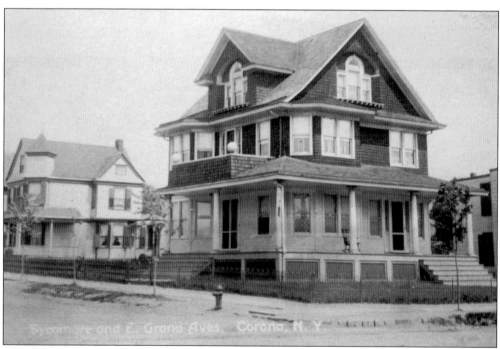

STATELY HOMES. When done with a measure of thoughtfulness and good taste, as seen in this grand Queen Anne–style corner house built in the early 20th century off Sycamore Avenue (104th Street) and East Grand Avenue (Roosevelt Avenue), development can indeed have a positive impact on local surroundings.

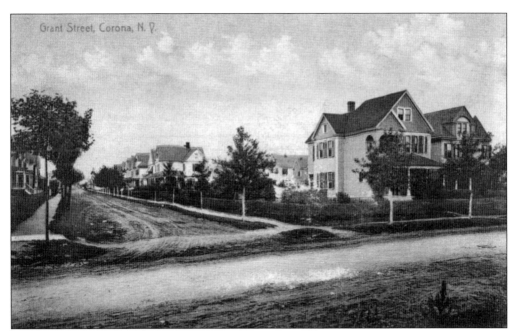

MODERN CORONA TAKING SHAPE. This postcard image of Grant Street (105th Street) in the first decade of the 20th century depicts Corona as an up-and-coming residential village. While the unpaved streets still lend a rustic appearance, the lined up homes clearly illustrate Corona entering its suburban phase.

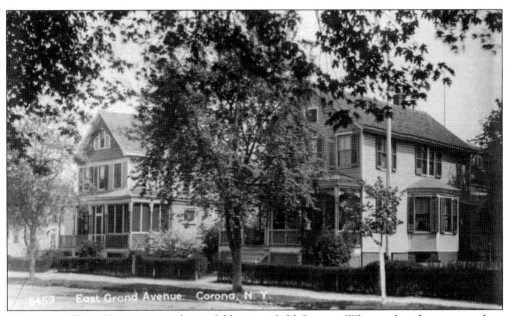

HOMETOWN FEEL. Here are more beautiful homes of old Corona. What makes this an appealing image is that these homes on East Grand Avenue, together with the surrounding trees, all lend to a small-town USA feel.

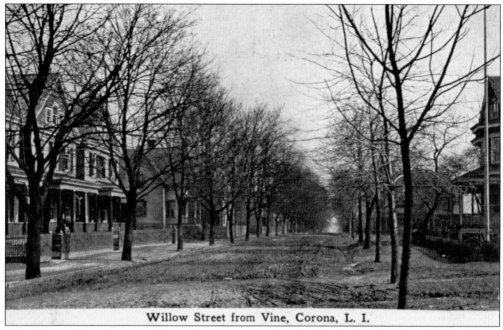

Willow Street from Vine, Corona, L. I.

NEW HOMES, OLD STREETS. Newer homes are seen here built side by side, along Willow Street (Forty-sixth Avenue) and Vine Street (Nicolls Avenue). Note how the unpaved surface has turned to mud during a cold and wet winter in 1915.

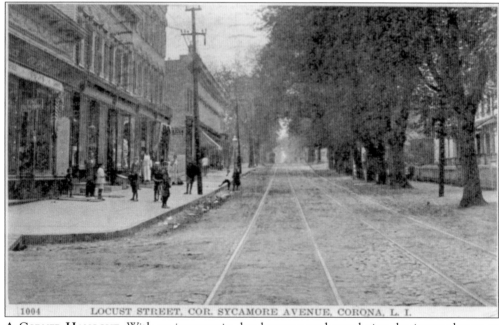

1004 LOCUST STREET, COR. SYCAMORE AVENUE, CORONA, L. I.

A CORNER HANGOUT. With an increase in development and population, businesses began to open in the thriving community. Here, a group of young boys hangs out in front of Volpes Shoe Repair Shop at the corner of Locust and Sycamore Avenues (104th Street).

48

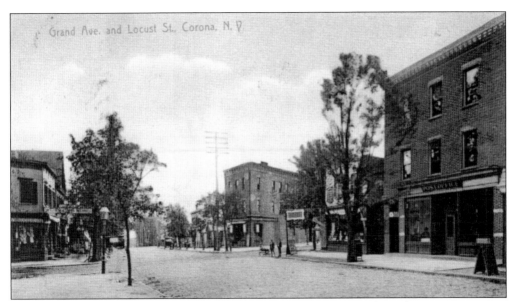

Grand Ave. and Locust St. Corona, N. Y.

POST OFFICE. Corona appeared on all the maps starting in 1873, when the US government established a new post office at the behest of Thomas Waite Howard. The post office can be seen on the far right at the intersection of Grand Avenue and Locust Street (Forty-third Avenue) in what was formerly Arcanum Hall.

THE FINAL DAYS OF SHADY LAKE. The Shady Lake farmhouse at Corona Avenue and 102nd Street was still standing when this photograph was taken in 1922. The farmland and lake from which John H. "Yankee" Smith cultivated his ice was long gone, and only the main home remained. It remained in the Smith family until it was torn down in 1928. (Queens Borough Public Library, Archives, Eugene L. Armbruster Photographs.)

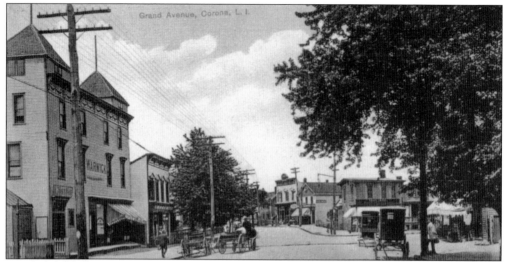

WARWICK HALL. Looking north up Grand Avenue (National Street) toward Roosevelt Avenue in 1910, Warwick Hall, situated on the left with its two conning towers, burned down on June 20, 1912. Warwick Hall was used as an entertainment space and a lecture hall. The buildings in the middle on either side of the block were demolished when Roosevelt Avenue was widened and the elevated road was built through a few years later.

DELLA CORTE. Built by John Heeg in 1883 across from the Coe homestead, this home was owned by several families, including Arthur Wagner in 1897, then William Geier. In the 1920s, the home was converted into a restaurant and inn called Della Corte. (Queens Borough Public Library, Archives, Eugene L. Armbruster Photographs.)

A Quick Lunch. To the left of the Della Corte Inn was a small one-level luncheonette that displayed the sign Quick Lunch & Soft Drinks. (Queens Borough Public Library, Archives, Eugene L. Armbruster Photographs.)

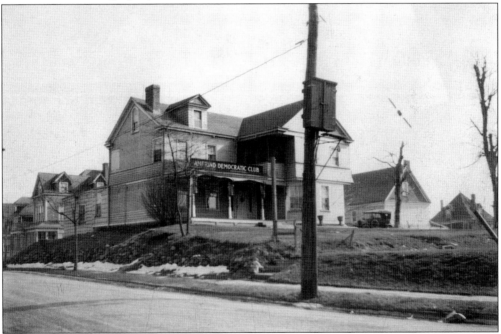

The Amerind Democratic Club. Located atop a small hill at Elmhurst Avenue near Denman Street, the Amerind Democratic Club built its headquarters here in 1922. The club was a major driving force behind many local Democratic leaders and was heavily involved in their election bids, including that of the borough president, members of the city council and state assembly, and even the mayor. Headed by Vincent Quinn, the club also threw an annual lawn party attended by some of the biggest movers and shakers in the New York Democratic society. (Queens Borough Public Library, Archives, Eugene L. Armbruster Photographs.)

Dr. R.C.F. Combes's Sanatorium. Dr. Combes's sanatorium was located on the south side of Northern Boulevard between 114th and 115th Streets. Combes relocated here in 1896 from Woodhaven after he sold that property for the creation of Forest Park. He died in 1915, and his brother Dr. Abbott C. Combes took over. (Queens Borough Public Library, Archives, Eugene L. Armbruster Photographs.)

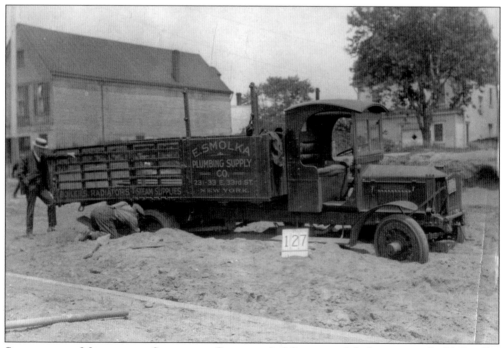

Stuck in the Mud on the Streets of Corona. A delivery truck belonging to the E. Smolka Plumbing Supply Company got stuck in the mud after one rainy day in the fall of 1924. (Queens Borough Public Library, Archives, Borough President of Queens Collection.)

CORONA FRUIT AND VEGETABLE MARKET. This old home on the corner of Thirty-seventh Avenue and 103rd Street was turned into the Corona Fruit and Vegetable Market in early 1920s. Many people in Corona, particularly in the Italian community, grew their own produce, which they sold to local grocers as a way of making extra income, especially during the Great Depression. (Queens Borough Public Library, Archives, Eugene L. Armbruster Photographs.)

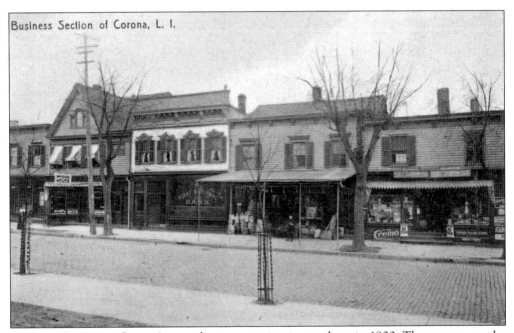

BUSINESS DISTRICT. Corona's main business section is seen here in 1900. These stores on the east side of National Street between Forty-third Avenue and the railroad crossing included the Balucci Bakery, the First National Bank of Corona, and Young's Village Store.

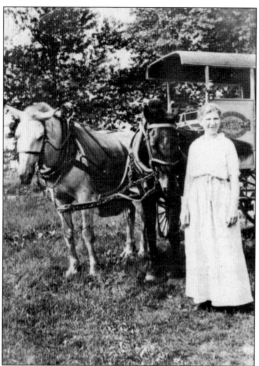

TRAVELING LIBRARY. Before physical locations were established, the Queens Borough Public Library would send these traveling book carriages into neighborhoods that had no branches to see if there was a demand for such services. This woman is shown standing beside the Flushing Branch of one of these traveling carriages, an early version of a bookmobile.

A TEMPORARY STATION. Kelly's Picture Store on Junction Avenue was the location of the early Corona traveling station of the Queens Borough Public Library in September 1910. It contained 800 books and proved to be so popular that it was decided that a regular branch was needed. (Queens Borough Public Library, Archives, Queens Borough Public Library Photographs.)

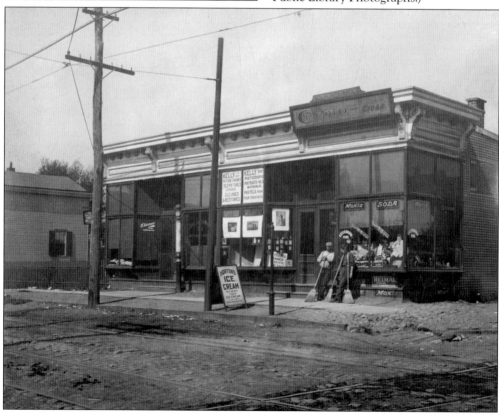

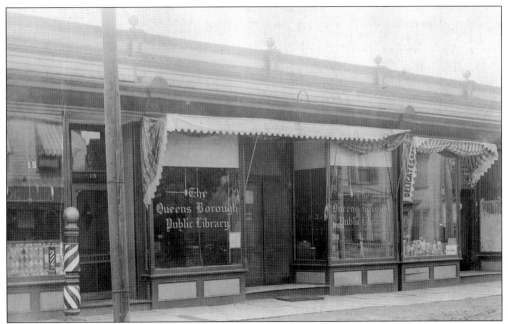

THE NEW LIBRARY. The Corona station moved into this rented storefront at 13 Locust Street (today the south side of Forty-third Avenue) just west of 102nd Street and was designated a public library branch on May 27, 1911. A separate building opened up three years later due to increased demand. (Queens Borough Public Library, Archives, Queens Borough Public Library Photographs.)

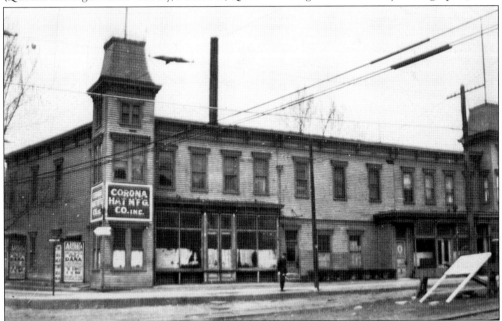

CORONA HAT MANUFACTURERS. At the northeast corner of Northern and Junction Boulevards was the Corona Hat Manufacturing Company Inc. The facility (seen as it appeared in May 1923) was built on the site of Pfeister's Roadside Inn, which opened in 1896, later became J. Carrolls Roadhouse, and was destroyed by fire. (Queens Borough Public Library, Archives, Eugene L. Armbruster Photographs.)

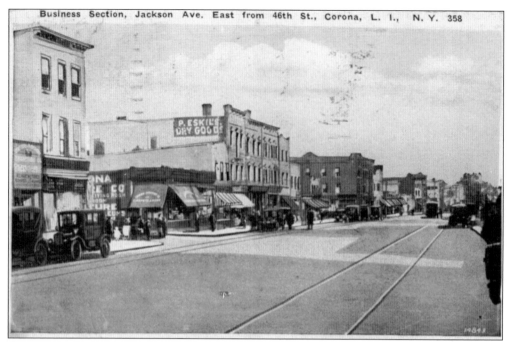

BUSINESSES ALONG NORTHERN BOULEVARD. The business section of Jackson Avenue looking east from Forty-sixth Street (today 103rd Street) shows the hustle and bustle of a typical workday in 1915. On the north side of the street is the Corona Furniture Company and P. Eskill's Dry Goods.

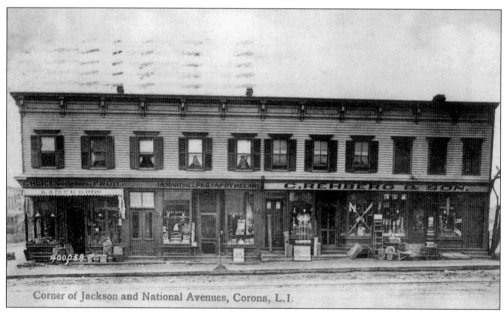

Corner of Jackson and National Avenues, Corona, L.I.

JACKSON AND NATIONAL AVENUES. The names on this humble strip of storefronts south of Northern Boulevard in 1909 reveal the ethnic diversity Corona was known to have. On the left there is the Kaiser brothers' fruit market while on the right appears to be a general store owned by C. Rehberg and Sons. Interestingly, in the center is an apothecary owned by A. Martinez, a name that foreshadows the modern-day presence of Corona's Latino population.

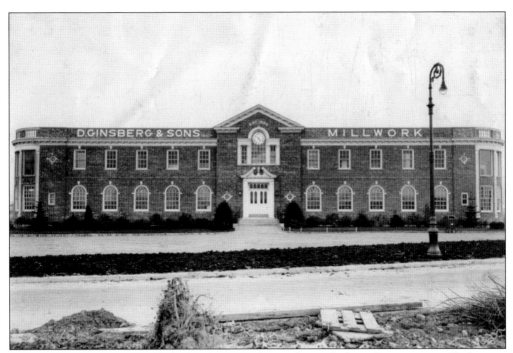

D. GINSBERG & SONS. Established in 1890 on the outskirts of where Corona meets Flushing at 112-01 Northern Boulevard, the D. Ginsberg & Sons Millworks provided materials for home builders. Hyman Ginsberg, who is spotlighted later in this chapter, founded the company. The building still stands today and is now the Tully Corporation. (Queens Borough Public Library, Archives, Chamber of Commerce of the Borough of Queens Collection.)

CORONA FARMS. Even into the 1920s, parts of Corona remained as farmland, with several farms of various sizes still in operation, as shown in this photograph dated November 8, 1926. This view looks north at 108th Street, which had yet to be cut through from a vantage point along Sixty-second Drive.

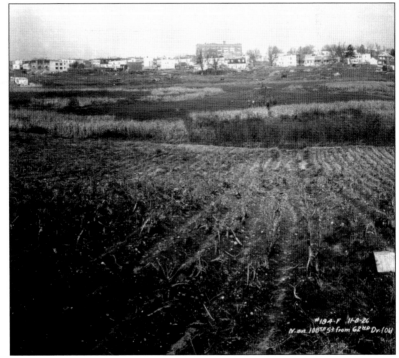

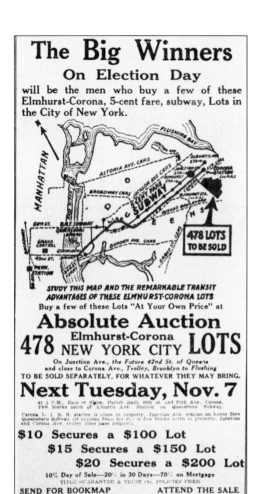
THE NO. 7 LINE IN CORONA. One the most important events in the history of Corona was the building of the elevated road above Roosevelt Avenue. Although Corona at this time was populated and established, it still remained a simple village with an easygoing way of life. The Interboro Rapid Transit (IRT) No. 7 Line, however, physically linked Corona with Manhattan by 1917 with a traveling time of 25 minutes for only a 5¢ fare. This brought about a new and intense wave of development, bringing to an end many of the old rural properties.

BUILDING THE NO. 7 LINE. Construction of the elevated road for the No. 7 train began in September 1913. Workers moved fast, building a block-long section per week with a great iron derrick called a "traveler" picking up and placing 20-ton iron girders. The construction attracted crowds from Corona and Flushing daily.

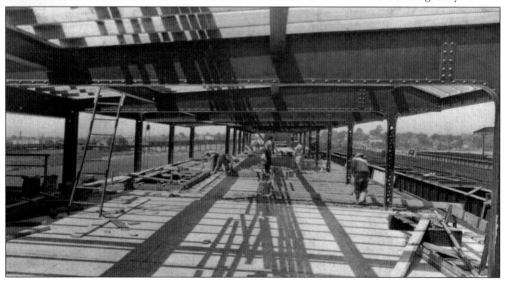

ROOSEVELT AVENUE TRANSIT ASSOCIATION. The men of the RATA gathered to celebrate the grand opening of the IRT elevated roadway on Saturday, April 21, 1917. Some 5,000 people gathered in Linden Park for a grand celebration. The first train left Grand Central Station at 2:30 p.m. and arrived at 104th Street in just 16 minutes. The train, filled with dignitaries, was greeted by the IRT Subway Band, and festivities continued well into the evening. The first passengers were invited on a free excursion the following day. (*Brooklyn Daily Eagle.*)

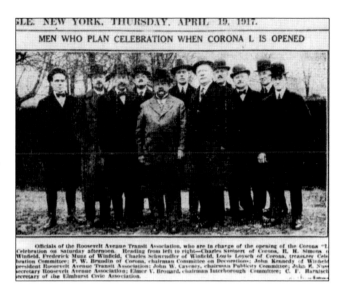

LE. NEW YORK, THURSDAY, APRIL 19, 1917.

MEN WHO PLAN CELEBRATION WHEN CORONA L IS OPENED

Officials of the Roosevelt Avenue Transit Association, who are in charge of the opening of the Corona "L" Celebration on Saturday afternoon. Reading from left to right—Charles Siemert of Corona, R. H. Simons of Winfield, Frederick Munz of Winfield, Charles Schwendler of Winfield, Louis Loyach of Corona, treasurer Celebration Committee; P. W. Brandin of Corona, chairman Committee on Decorations; John Kennedy of Winfield, president Roosevelt Avenue Transit Association; John W. Caveney, chairman Publicity Committee; John K. Nast, secretary Roosevelt Avenue Association; Elmer V. Brouard, chairman Interborough Committee; C. F. Harnisch, secretary of the Elmhurst Civic Association.

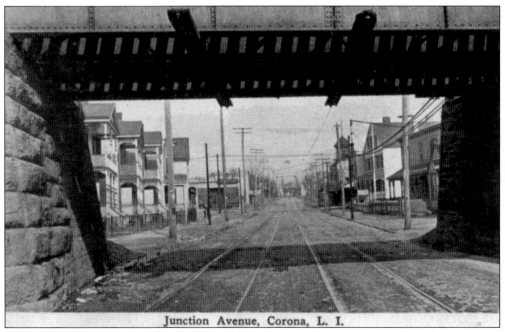

Junction Avenue, Corona, L. I.

LIRR BRIDGE AT JUNCTION AVENUE. The LIRR also played a prominent role in the expansion of Corona, allowing passengers coming from as far as Long Island to enjoy and even settle in this remarkable neighborhood. This overpass is situated near Junction Boulevard and Forty-third Avenue.

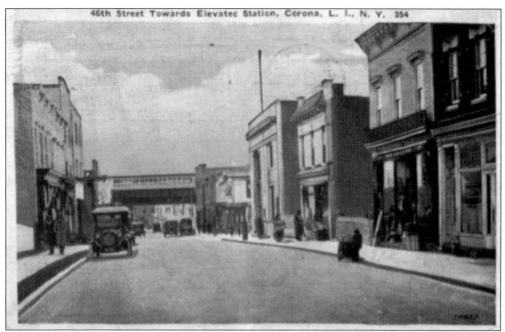

IRT Overpass. This view is looking toward Roosevelt Avenue from 103rd Street in the early 1920s. On the right is the Queensboro Department Store.

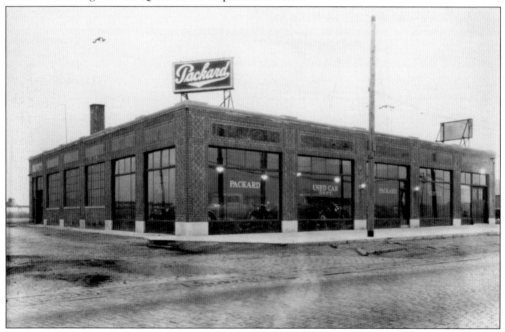

Packard Dealership. In 1854 came the LIRR, then the IRT No. 7 Line in 1917. In addition to these, by the 1920s the automobile became a popular method of transportation, making Corona still more accessible than ever before. This Packard Motor dealership was one of numerous car dealerships that appeared along major parkways throughout Queens. This facility was located at 126-56 Northern Boulevard. (Queens Borough Public Library, Archives, Chamber of Commerce of the Borough of Queens Collection.)

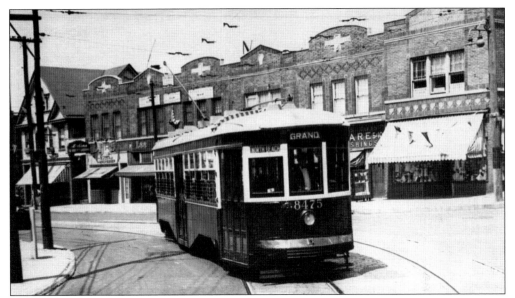

THE CORONA TROLLEY. The trolley debuted on May 27, 1894, first operated by the Brooklyn Heights Railroad Company. Other trolley lines would service the area, including the Queens County Railway. Seen here is the Grand Avenue trolley at Corona Avenue and Ninety-first Place on June 26, 1939, bound for North Beach and the NYC Municipal Airport (now LaGuardia Airport). Service along this line was discontinued on August 25, 1949.

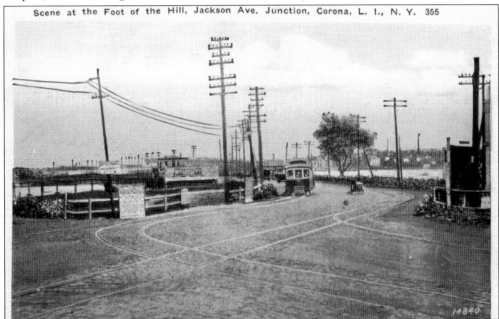

SHELL ROAD AND NORTHERN BOULEVARD, 1925. The trolley operating via the Queens County Railway is seen here traveling west toward Corona from Flushing. In this postcard view, the trolley has just crossed over the Corona border at the intersection of what was known as the Shell Road. The name originates from when the road was paved with crushed oyster shells. This line was abandoned on August 3, 1925. Today, the Grand Central Parkway crosses through the middle of this scene.

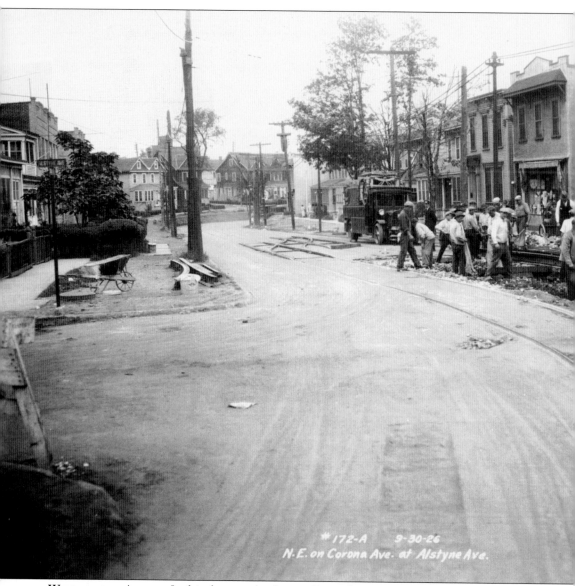

#172-A 9-30-26
N.E. on Corona Ave. at Alstyne Ave.

WIDENING THE AVENUE. In this photograph taken on September 30, 1926, workmen under the orders of the Queens Topographical Bureau widen Corona Avenue at its junction with Alstyne Avenue. The widening of streets became commonplace in Queens during the late 1920s through the 1930s, when both trolley and automobile had to share the road. (Queens Topographical Bureau.)

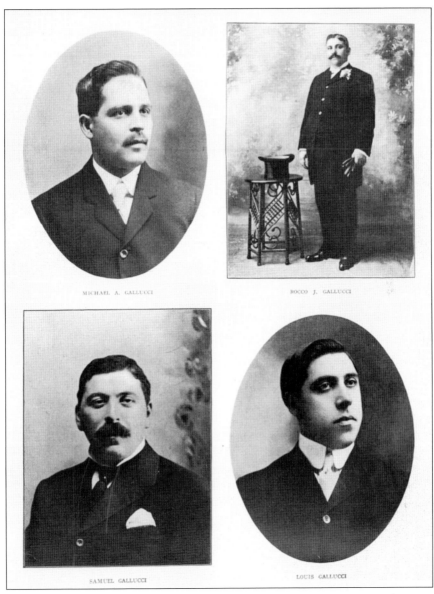

MICHAEL A. GALLUCCI

ROCCO J. GALLUCCI

SAMUEL GALLUCCI

LOUIS GALLUCCI

THE GALLUCCI NAME. By the turn of the 20th century, a sizable number of Italians settled in Corona. Some were civic minded and became pillars of the community. Among them were four men who shared the surname Gallucci. Michael Gallucci (upper left) was a Corona resident from as early as 1888. Michael attended local public schools and Newtown High School; he later went on to earn a bachelor of laws degree. Rocco Gallucci (upper right) emigrated to the United States when he was 12. After being schooled in Italy, Rocco also attended local public school. Being a longtime Corona resident before he married, it was where he also chose to raise his family. Rocco became a real estate agent and notary by profession. Samuel Gallucci (lower left) arrived in New York City with his parents and was enrolled in the public schools. In time, Samuel established what would become a prominent plumbing and steam heating appliance establishment in Corona, with as many as 75 men under his employ. It was said that Samuel's business was the largest of its kind on Long Island. Louis Gallucci (lower right) graduated from New York Law School with an bachelor of laws degree in 1904. Louis too was a longtime resident of Corona.

FRANK A. BELLUCCI

FRANK BELLUCCI, ESQ. Another prominent Italian immigrant in Corona was Frank Bellucci, who graduated from New York Law School and was admitted to the bar in 1919. In one locally visible case in 1935, Bellucci took on state superintendent of insurance George S. Van Schaik. In a bill of particulars sent to then governor Herbert Lehman through the Queens and Brooklyn District Attorneys' office, Bellucci charged Van Schaik and his office of willful dereliction in processing 20,000 real property foreclosures, which he estimated cost homeowners a whopping $800 million. This, in his words, constituted "both misfeasance and malfeasance . . . warranting immediate and drastic action." (Queens Borough Public Library, Archives, Portraits Collection.)

HYMAN GINSBERG

HYMAN GINSBERG OF GINSBERG & SONS. This portrait is of Hyman Ginsberg, founder of a Corona-based industry dealing in the production and distribution of sash, doors, and trim for home builders. Born in Russia in 1867, he arrived in America in 1888. A veteran businessman by the time he resided in Corona in 1907, he ran a prominent factory, Ginsberg & Sons, located on 81 Lincoln Street, that no doubt assisted many who built and maintained homes in the area. (Queens Borough Public Library, Archives, Portraits Collection.)

DISGRACED QUEENS POLITICO. Borough Pres. Maurice Connolly (1880–1935) was born and raised in Corona. Starting his political career early in life, he quickly rose through the ranks of the local Democrat machine. He was appointed assistant commissioner of taxes in February 1904, but his star reached its apogee in 1911 when he was elected Queens borough president. He would keep this post for the next 17 years until a scandal over the issuance of sewer contracts in Queens uncovered that he and his associates took $9 million in bribes. After stepping down as borough president, Connolly was found guilty of conspiracy to defraud the city and would serve a year in prison. He died in his Forest Hills home and was buried in Flushing's Mount St. Mary's Cemetery.

M. C. CONNOLLY

Magistrate for the 1st, 2d and 3d Districts, City Magistrate's Court
Borough of Queens

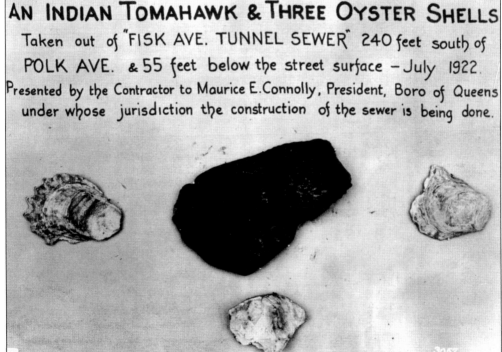

AN INDIAN TOMAHAWK & THREE OYSTER SHELLS

Taken out of "FISK AVE. TUNNEL SEWER" 240 feet south of POLK AVE. & 55 feet below the street surface – July 1922.
Presented by the Contractor to Maurice E. Connolly, President, Boro of Queens under whose jurisdiction the construction of the sewer is being done.

ARCHAEOLOGICAL DISCOVERIES. During the July 1922 excavation of the sewer tunnel near Polk Avenue (Thirty-seventh Avenue), these oyster shells and tomahawk blade were discovered more the 50 feet below the surface.

LAYING DOWN THE SEWER LINE. Before the modern sewer line, Corona village relied on cesspools. These became totally inadequate as the village's population grew. Cesspools would overflow into the streets, and during World War I, several cases of typhoid broke out. (Queens Borough Public Library, Archives, Borough President of Queens Collection.)

Typhoid Mary. One of the most incredible medical dramas in the city's history was the case of Mary Mallon. Born in 1869 in Cookstown, County Tyrone, Ireland, Mallon immigrated to America in 1883 and found work as a cook for wealthy families. Wherever Mallon worked, people got sick. After working for several families that resulted in multiple illnesses, she took a position in Oyster Bay, Long Island, for a family of 11 members; 10 of them got sick. After a thorough medical investigation, Mallon was the first person in the United States to be an asymptomatic carrier of the pathogen associated with typhoid fever. She infected 51 people, 6 of whom died. She was twice isolated by public health authorities and died after a total of nearly three decades in isolation on North Brother Island in the East River.

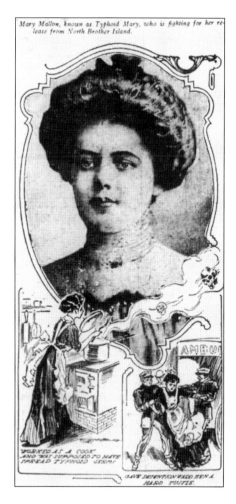

Mary Mallon, known as Typhoid Mary, who is fighting for her release from North Brother Island.

WORKED AS A COOK AND WAS SUPPOSED TO HAVE SPREAD TYPHOID GERMS.

GAVE DETENTION WARD MEN A HARD TUSSLE.

HOSPITAL EPIDEMIC FROM TYPHOID MARY

Germ Carrier, Cooking Under False Name, Spread Disease in Sloane Institution.

CAUGHT HIDING IN QUEENS

Blamed for Twenty-five Cases of Fever Among Doctors and Nurses —Now In Quarantine.

Captured in Corona. After she was released from isolation, Mallon was given a job as a laundress. However, she broke the promise and returned to cooking. Soon there were outbreaks of typhoid once again. As reported in the *New York Times* on March 28, 1915, "A squad of sanitary police who had been immunized against typhoid . . . surrounded the house." In order to capture the woman the newspapers named Typhoid Mary, authorities climbed up to the second floor of the boardinghouse on Corona Avenue. It was here that they came face to face with a ferocious bulldog. They retreated only to return with a piece of meat, which subdued the animal. Police made another attempt and successfully entered to find Mary Mallon hiding in the bathroom. She surrendered peacefully.

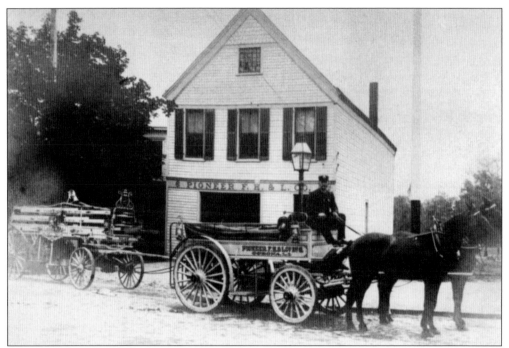

PIONEER FIRE HOOK & LADDER COMPANY NO. 6. Corona had two volunteer fire departments. The Pioneer Company had been organized in 1890 and survived to celebrate its 20th anniversary in March 1910. It was discontinued soon thereafter. The Pioneer Company owned its own building on National Street, a hose wagon with 900 feet of hose, a hook and ladder truck, and a jumper with a reel of 500 feet of hose. Its members included the commissioner of public works for Queens County Joseph Sullivan and First National Bank of Corona president William J. Hamilton. As Corona became more developed, a dedicated working fire company was needed.

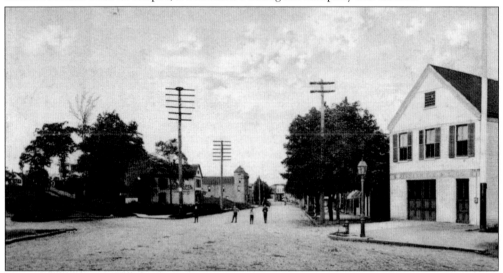

PIONEER FIREHOUSE. Pictured here is the headquarters of the Pioneer Fire Hook & Ladder Company No. 6, looking down Grand Avenue (Thirtieth Avenue) near Mulberry Avenue (102nd Street). When the paid fire department took over, the company was renamed Engine Company No. 289. That company disbanded in 1914. The firehouse at right still stands today as a retail store.

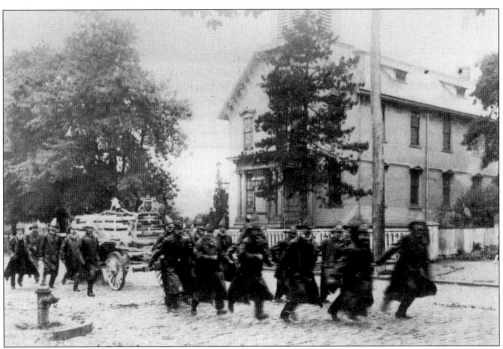

LOUONA ENGINE COMPANY NO. 8. Known as "Looney Eights," the Louona Engine Company earned the name after a wild New Year's party on January 1, 1910, during which the headquarters of the company on 103rd Street between Northern Boulevard and Thirty-second Avenue in Louona Park was ironically destroyed by fire. All the records of the company were lost. A decade later, on September 9, 1920, after occupying several locations around Corona, the firemen found a new home on the north side of Thirty-second Avenue close to 102nd Street. The men of the 27-member company are seen marching past Union Church on June 20, 1896, on the way to their new quarters in this rare photograph. (Vincent F. Seyfried Collection.)

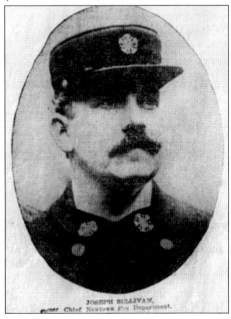

PIONEER HOOK & LADDER FOREMAN JOSEPH SULLIVAN. Former chief of the Newtown Fire Department and commissioner of public works for Queens County, Joseph Sullivan was a prominent member of the Pioneer Fire Hook & Ladder Company No. 6. It was Sullivan, along with other members, who set aside their daily activities to bravely respond to fires and other emergencies. His portrait was featured in the September 1906 issue of the *Flushing Daily Times* in its special salute to Queens firefighters edition.

The Exempt Fireman's Association

OF THE

TOWN OF NEWTOWN, BOROUGH OF QUEENS, NEW YORK CITY,

Headquarters : Fireman's Hall, Ludlow Ave,, near Fifth St., Elmhurst.

November 12, 1904.

DEAR SIR:

Your are hereby notified to attend a SMOKER of the Exempt Firemen's Association of the Town of Newtown to be held at our headquarters, Company No. 11's house, Ludlow Avenue, near Fifth Street, Elmhurst, on **TUESDAY EVENING, Nov. 15, 1904.** All Firemen of the Newtown Fire Department are invited to be present with us and enjoy the good time that the Committee has provided and arranged for.

☞ **Please Forward Your Correct Post Office Address.** ☜

JAMES McCRON, Secretary,

16 West Shell Road, CORONA, L. I.

AN INVITATION TO A SMOKER. This invitation dated November 12, 1904, was sent to people to come and enjoy a party, or "smoker," to benefit the Exempt Fireman's Association on November 15. It was held at the headquarters of Company No. 11 on Ludlow Avenue and Fifth Street (Forty-third Avenue and Ninety-first Place) in Elmhurst.

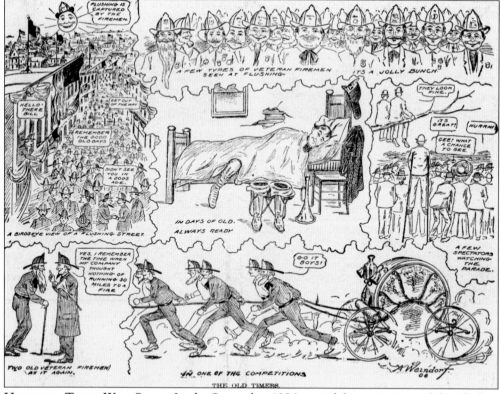

HONORING THOSE WHO SERVE. In the September 1906 special fireman's issue of the *Flushing Daily Times,* this cartoon honored the memory of all the volunteer firefighters who served Queens County through the years, risking their lives to save others.

70

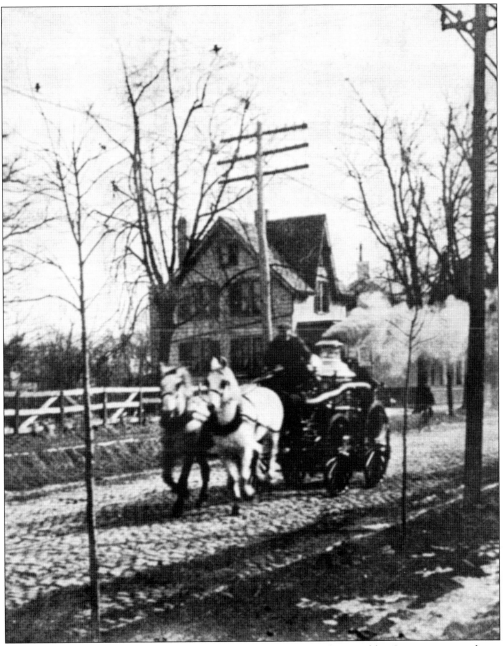

THE LAST CALL. A horse-drawn steamer from the Pioneer Hook & Ladder Company races down a brick-paved Junction Boulevard in 1910 on its way to a fire.

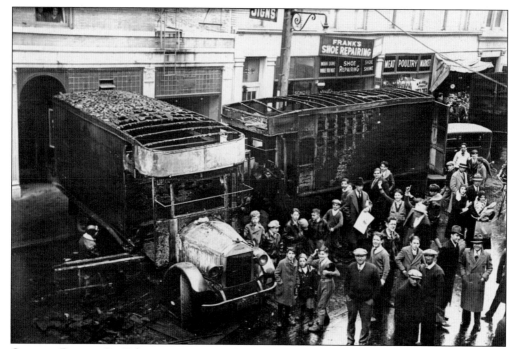

CORONA BLAZE. On February 9, 1932, a devastating fire broke out in this one-story garage, damaging four large moving vans. The two shown here bore the brunt of the conflagration. The Fire Department of New York (FDNY) put the fire under control.

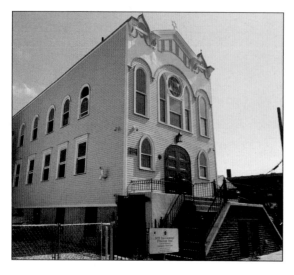

TIFERETH ISRAEL. There were two Jewish areas, Corona Heights and Corona Park. Congregation Tifereth Israel (Splendor of Israel) at 109-20 Fifty-fourth Avenue is an Orthodox synagogue founded by Ashkenazi Jews who came to Corona from Manhattan's Lower East Side. The congregation constructed the synagogue, a wooden Gothic and Moorish Revival–style structure designed by Crescent L. Varrone in 1911. Tifereth Israel is today the oldest synagogue building in Queens continuously used for worship. Corona native Josephine Esther Mentzer, known as Estée Lauder of cosmetic fame, attended services here.

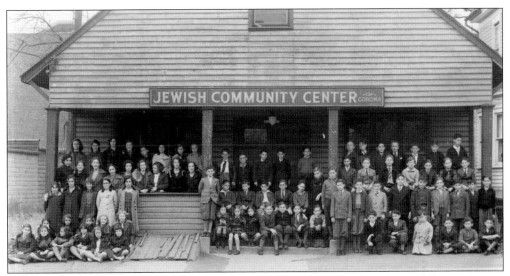

JEWISH COMMUNITY CENTER OF CORONA. This structure was originally built as St. Bartholomew's English Lutheran Church in 1911 on the west side of 102nd Street between Fortieth Road and Forty-first Avenue. In 1913, it became the Zion African Methodist Episcopal Church and then Forester's Hall in March 1917. Two decades later, the building yet again became home to another tenant: the Jewish Community Center of Corona. The address of where this wooden structure once stood is 43-07 104th Street.

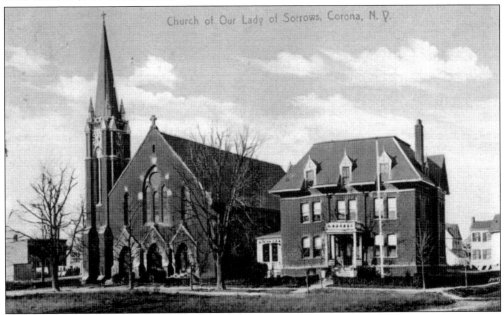

OUR LADY OF SORROWS. Located on the northeast side of 104th Street and Thirty-seventh Avenue, Our Lady of Sorrows sits on eight lots that were once part of the Fashion Race Course. The property was acquired by Fr. Ignatius Zeller of St. Mary's in Winfield (Woodside). Organized in 1870, a small framed church was dedicated in 1872. As the congregation increased, additional lots were purchased, and construction began on a larger church. The cornerstone was laid on October 29, 1899, and the church was dedicated on September 16, 1900. It cost $32,000 to build. A brick convent located on the right was built in 1916 for the sisters of St. Joseph.

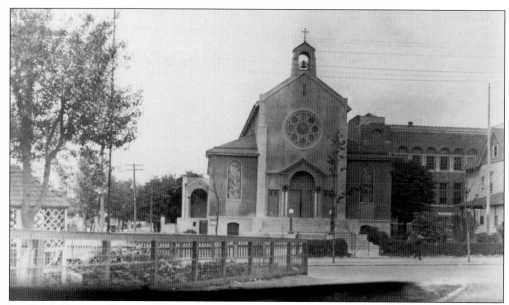

St. Leo's Roman Catholic Church. This parish was organized in 1903 as a mission to the growing Italian community in Corona. The cornerstone was laid on May 29, 1904, and mass was first observed on November 1, 1903. On November 13, 1905, the church was dedicated and the rectory completed. The contractor of the church, located at the southeast corner of 104th Street and Forty-eighth Avenue, was James A. Stevenson of Long Island City. The church is pictured here after it was remodeled. (Queens Borough Public Library, Archives, Frederick J. Weber Photographs.)

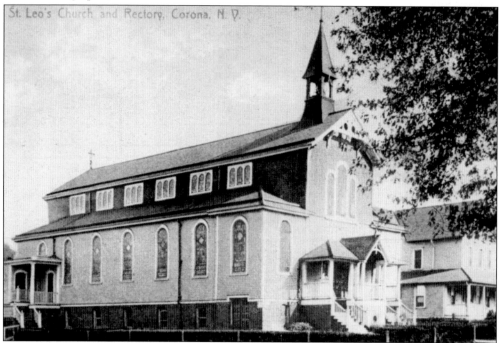

Original St. Leo's. This postcard shows the original facade of St. Leo's Roman Catholic Church.

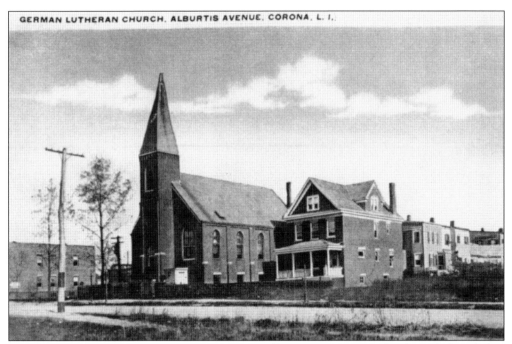

EMANUEL GERMAN LUTHERAN CHURCH. Originally a German Evangelical parish founded in November 1887, the cornerstone was laid on October 4, 1896, and a stone church was erected at the southeast corner of 104th Street and Thirty-seventh Avenue. Built at a cost of $15,000 in 1902, the church also erected a 2.25-story parsonage in 1914.

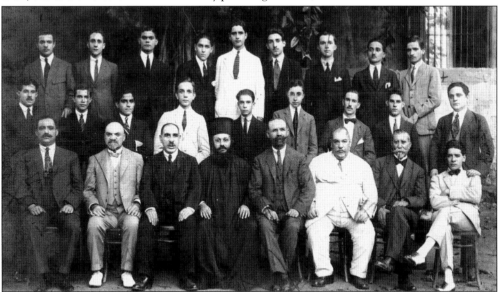

CORONA'S GREEK ORTHODOX PRESENCE, 1928. Corona's Greek community held its first service in a former storefront on Roosevelt Avenue on Palm Sunday in 1926. Later, this humble parish moved to Thirty-eighth Avenue and Ninety-ninth Street, remaining there until 1957. Depicted is the first parish council under Fr. Alexandros Gerontidakis (first row, fourth from left), who served as priest and schoolteacher, underscoring the values of the growing number of Greeks in the area.

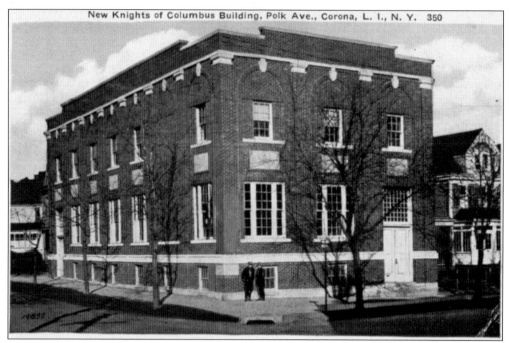

KNIGHTS OF COLUMBUS. The hall of the Corona chapter of the Knights of Columbus was located on Polk Avenue (Thirty-seventh Avenue).

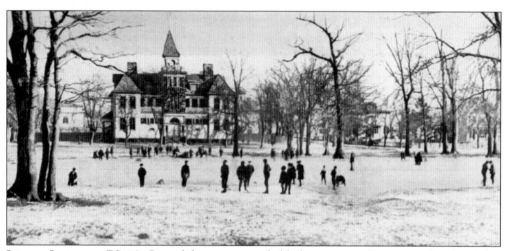

LINDEN LAKE AND PS 16. One of the most remarkable locations in Corona was Linden Lake. When frozen over, the lake was perfect for skating. When the lake was drained in 1912 by the city's parks department, workers discovered goldfish, eels, and turtles. Several hundred large fish weighing more than a pound were also uncovered.

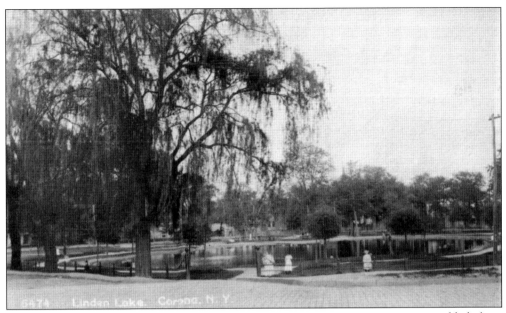

LINDEN LAKE. After renovations by the parks department in 1913, new water was added along with goldfish. A promenade was constructed around the lake in the fall, and the following year, Norway maples were planted around the park. In 1916, new lighting was added to the park so that it could be enjoyed in the evening.

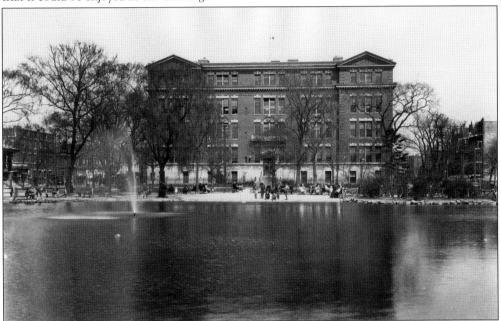

A NEW LAKE, A NEW SCHOOL. This photograph looking from 104th Street and Forty-first Avenue shows a newly rebuilt PS 16 overlooking a refurbished Linden Lake with a fountain in the center. The parks department installed flowers every year, and the students of PS 16 tended to them during the spring and summer. After World War II, Linden Lake was considered a health hazard and covered up in 1947. (Queens Borough Public Library, Archives, Frederick J. Weber Photographs.)

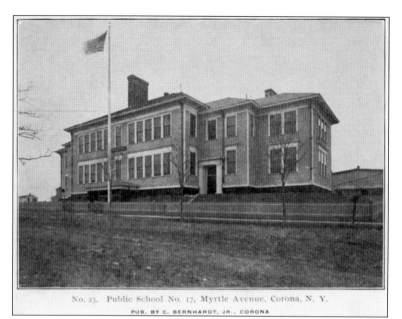

No. 23. Public School No. 17, Myrtle Avenue, Corona, N. Y.

PUB. BY C. BERNHARDT, JR., CORONA

PS 17. Old Public School No. 17 stood on Myrtle Avenue (111th Street) between Fifty-first and Fifty-second Avenues in Corona Heights and was constructed in 1897 with 15 classrooms.

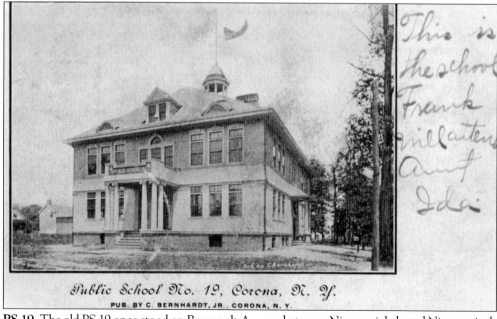

Public School No. 19, Corona, N. Y.

PUB. BY C. BERNHARDT, JR., CORONA, N. Y.

PS 19. The old PS 19 once stood on Roosevelt Avenue between Ninety-eighth and Ninety-ninth Streets near the Leverich Woods. Constructed in 1899, it contained eight classrooms.

PS 18. The old PS 18 was located on Corona Avenue and 104th Street. This image was taken on June 7, 1927. (Queens Borough Public Library, Archives, Eugene L. Armbruster Photographs.)

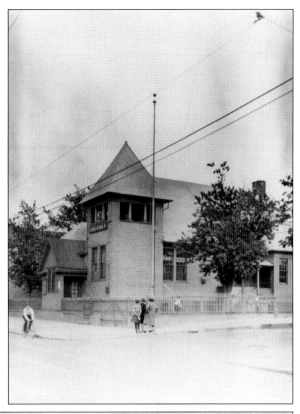

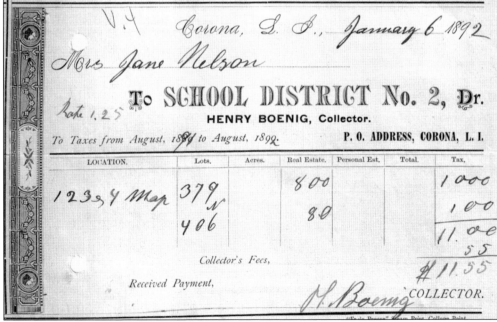

SCHOOL DISTRICT NO. 2. One of the powers derived from incorporation was to levy taxes of all kind, including school taxes, as displayed by this receipt from 1892. Taxes amounted to $11.55. School District No. 2 was established around 1870.

PS 14 Class Photograph. This grade-school class photograph was taken in June 1937. (Rob Trombley.)

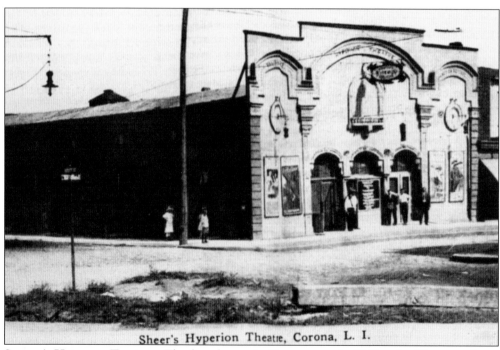

Sheer's Hyperion Theatre, Corona, L. I.

Scheer's Hyperion Theater. The first theater in Corona was the El Dorado. The second was built by the Scheer brothers of Corona and named the Hyperion Theater, located on the southeast corner of Thirty-ninth Avenue and National Street. It featured three Moorish arches on its exterior and offered a matinee and evening program with dancing every Monday, Wednesday, and Friday. Adults were charged 15¢ and children 10¢. (Queens Borough Public Library, Archives, Post Card Collection.)

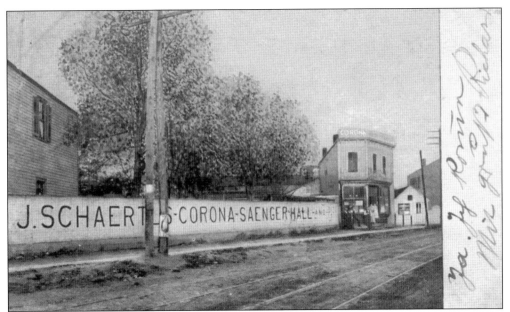

J. Schaertl's-Corona-Saenger Hall. Located at Corona and Fifty-first Avenues, this hall was home of the German Men's Chorus (or Maennerchor in German).

Base Ball Field, Corona, L. I.

Baseball in Corona. Baseball has special roots in Corona. At its beginning, baseball was almost exclusively a private gentleman's sport and excluded spectators, as games were held solely for the benefit of those involved. This changed in 1858, when the best players from Brooklyn met the best from Manhattan at the Fashion Course for a three-game series held for charity. Thousands came to witness the event, which lasted from August 15 to 17. Brooklyn lost to New York two games to one. The event proved that people would pay money to see the finest players of the game compete. Thus, it was here that baseball became a professional sport. This postcard shows a game played at Northern Boulevard and 100th Street in 1914. In the background is Charles Maas's roadhouse and saloon.

A Funeral Procession. In this rather somber photograph, an Italian funeral march is about to begin on a dreary day along 108th Street in the early 1920s near where the famous Parkside Restaurant and bocce ball courts now stand. (Parkside Restaurant.)

Jamaica High School Tennis Team. This c. 1933 photograph shows the Jamaica High School Men's Tennis Team at the short-lived Corona Golf Course, which was located in Flushing Meadows. Behind them is the clubhouse. The entire facility was torn down in 1936. (Queens Borough Public Library, Archives, Frederick J. Weber Photographs.)

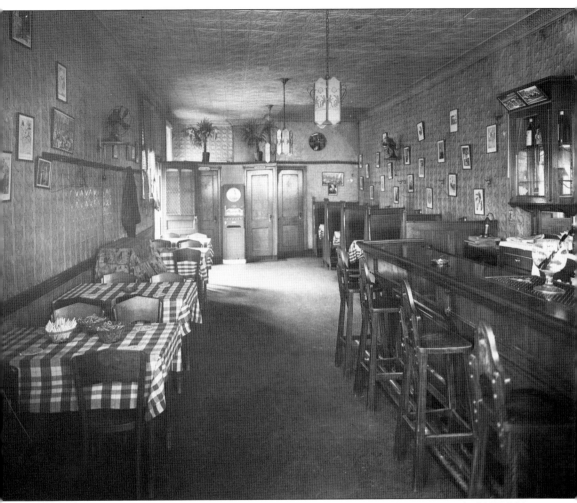

Walsh's Bar & Grill. At 40-10 Junction Boulevard was the popular watering hole Walsh's Bar & Grill. Note the saltine crackers and pretzels on the table at left, the glass of hard-boiled eggs on top of the bar to the right, and the cigarette machine in the center back. On the walls are decorative photographs of famous horse races. (Queens Borough Public Library, Archives, Frederick J. Weber Photographs.)

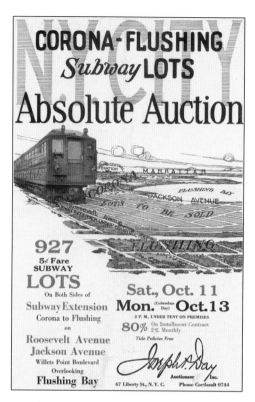

SUBWAY LOT AUCTION BROCHURE. This profusely illustrated brochure advertises the auction of 927 lots along both sides of the IRT subway extension near Roosevelt Avenue, Jackson Avenue (Northern Boulevard), and Willets Point Boulevard. The land auction was held on Saturday, October 11 and Monday, October 13, 1924. The subway extension from Corona to Flushing marked the final stage of the IRT No. 7 line's journey from Manhattan's Forty-second Street to Flushing's Main Street. That station in Flushing opened in 1928.

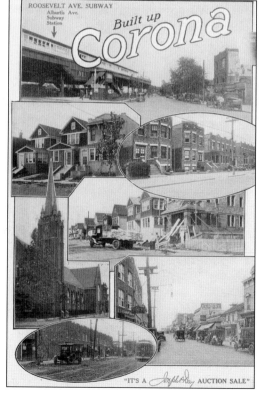

BROCHURE CONTINUED. To lure prospective buyers, the inside of the brochure advertised a "Built Up Corona" with scenes of Corona Plaza, the Roosevelt Avenue IRT stop, 103rd Street, Junction Avenue, and even Our Lady of Sorrows Church.

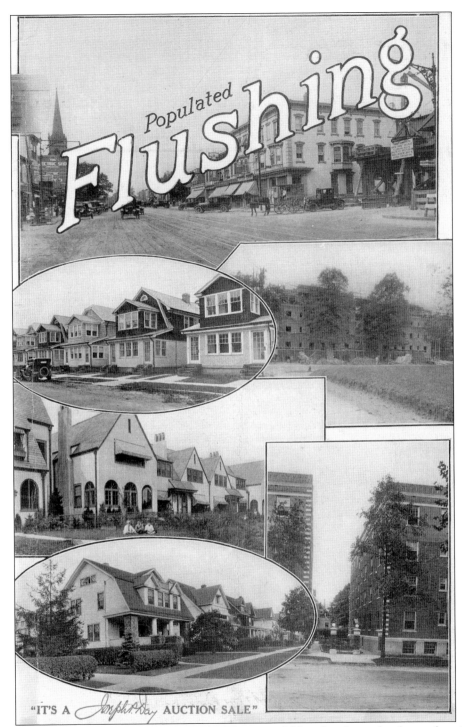

Populated *Flushing*

"IT'S A *Joseph P. Day* AUCTION SALE"

POPULATED FLUSHING. The opposite panel of this same foldout brochure also featured exciting scenes of Flushing, which was undergoing its own expansion and development in anticipation of the IRT's arrival, bringing future customers from the city. The top image of this montage shows Main Street looking north.

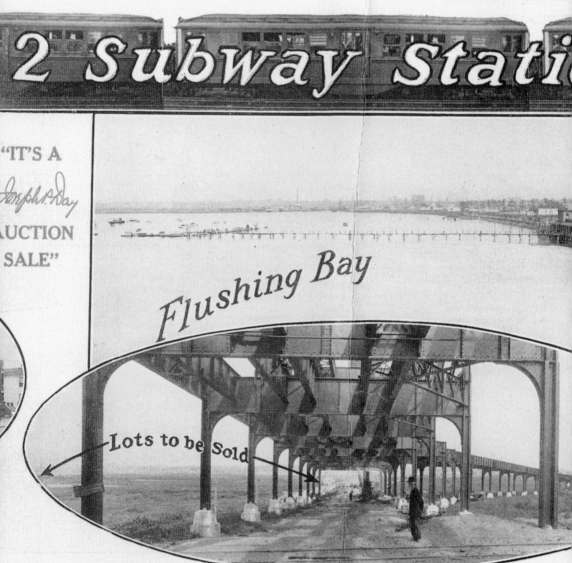

These 927 5¢ Fare Subway Lots a

on both sid

2 Subway Stati

"IT'S A

Joseph P. Day

AUCTION
SALE"

Flushing Bay

Lots to be Sold

Subway under construction on Roosevelt Ave. through these Corona-Flush

JOINING CORONA AND FLUSHING. The centerfold of the auction brochure offers a panorama of three incredible views. On the lower left is a photograph of the unfinished elevated trestle of the IRT over Roosevelt Avenue. The avenue itself did not open until 1919. Note the empty lots for sale on either side. On the right are the trestle's steel components waiting to be assembled

right between these Two Centres

f New Subway to Flushing

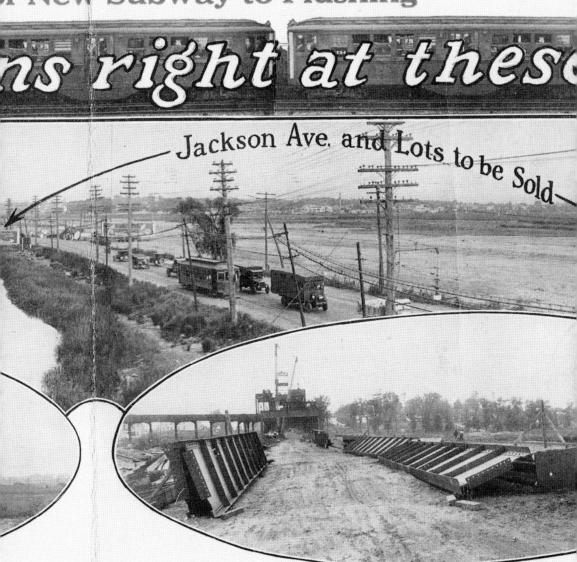

Jackson Ave. and Lots to be Sold

Another view of the subway extension through Roosevelt Ave. l

ts

above Roosevelt Avenue on the way to Flushing. In the center is Jackson Avenue (now Northern Boulevard) with trolleys and automobiles going in between Corona and Flushing. Note how the Flushing Bay comes right up to the boulevard. Today, this part of Northern Boulevard is underneath the Whitestone Expressway overpass and has been widened by hundreds of feet.

*507-A 6-9-27

Park Triangle at Intersection of Corona Ave. & 108ᵀᴴ St.

SPAGHETTI PARK. The triangle at the intersection of Corona Avenue and 108th Street is known as Spaghetti Park. In the center of the park are bocce ball courts, which is still the heart of the Italian community in Corona. One of New York City's most famous restaurants, Parkside, is still in business today and frequented by all those who live in Corona; celebrities of the art, entertainment, and literary world; and even local politicians. (Queens Topographical Bureau.)

Four

A HORSERACING LEGACY

While some in West Flushing saw the makings of a new residential village, others, in particular a southern-based group called the National Racing Association, looked to seize its potential as a horseracing venue. By din of construction around the clock over the winter months, the National Race Course first opened its gates to the public on June 26, 1854. It was by all accounts a sight to see and the place to go: "Suffice it to say that it seems to be perfect in its arrangements and upon a scale of peculiar magnificence that will allure and fascinate a class which have hitherto kept aloof from this amusement by reason of its offensive associations," commented the *Flushing Journal*.

Happily, opening day coincided with the Flushing Railroad's maiden arrival to West Flushing, though passengers had to disembark some distance away at 108th Street (the National Street Station was to be built later). Any objection soon evaporated in the warm and festive air.

Soon after all the excitement faded, however, major troubles surfaced for the association. Due to the previous winter's storms and hurried workmanship, the racetrack's southern and western walls collapsed (fortunately, no one was hurt). Matters were so dire by January that default was certain. Luckily, a defect in the judgment averted foreclosure for the time being, giving the syndicate a chance to appeal to local benefactor DeWitt C. Grinnell to help pay the mortgage. He agreed, and afterward employed a Dr. Welden as his agent, who would head down south to pitch the virtues of West Flushing as a venue to wealthy Southern planters to race their horses.

Under Grinnell, the National Race Course was renamed the Fashion Race Course. It would also sport the Club House, a 22-room mansion that, as the name suggested, was intended to cater to the elite from Manhattan and elsewhere. Alongside was the comparatively modest Fashion House, a saloon for the ordinary patron, sportsman, or local track enthusiast. Yet in the summer of 1867, one's station in life mattered little: all in attendance were to witness history being made as the muscular trotter Dexter broke the world's trotting record. Everyone at the Fashion Race Course reveled in the moment. However, it was West Flushing that basked in the glory.

THE CLUB HOUSE. Local benefactor Dewitt W. Grinell converted the 22-room Henry Colton Mansion, located at the northeast corner of Thirty-fourth Avenue and Ninety-eighth Street, into the esteemed clubhouse of the National Race Course, renaming it Grinell's Hotel. Historian Vincent Seyfried observed: "Fashionable dances were held in the glittering parlors and some of the most beautiful women of the day graced the salons with their presence. Distinguished foreigners were entertained here and elegant suppers attracted the notables of the day."

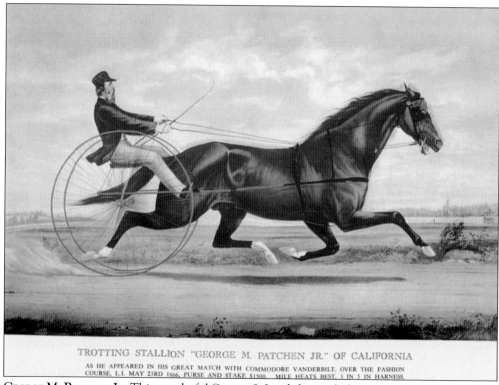

TROTTING STALLION "GEORGE M. PATCHEN JR." OF CALIFORNIA

AS HE APPEARED IN HIS GREAT MATCH WITH COMMODORE VANDERBILT, OVER THE FASHION COURSE, L.I. MAY 23RD 1866, PURSE AND STAKE $1500. MILE HEATS BEST, 3 IN 5 IN HARNESS.

GEORGE M. PATCHEN JR. This wonderful Currier & Ives lithograph depicts the handsome trotting stallion George M. Patchen Jr. that raced Commodore Vanderbilt at the National Race Course in Corona on May 23, 1866. The lithograph's caption says it all.

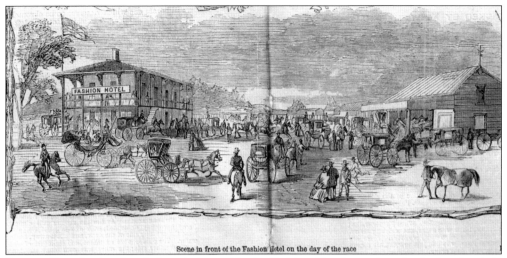

Scene in front of the Fashion Hotel on the day of the race

RACING DAY. In this detailed rendering, with the Fashion Hotel prominently displayed at left, one gets a sense of how popular a day at the races was. While a real-life photograph might have been more compelling, none exists. This image shows how eagerly a diversion like horseracing was sought after. (*Frank Leslie's Illustrated Newspaper.*)

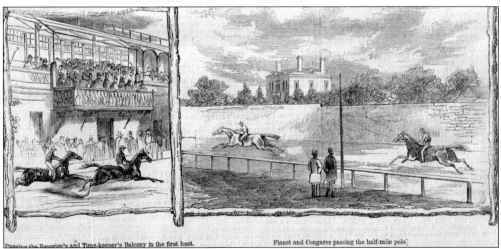

Passing the Reporter's and Time-keeper's Balcony in the first heat.

Planet and Conagree passing the half-mile pole

THE FASHION RACE COURSE. With split-second photography more than a century away, here are two fanciful images of races at the Fashion Race Course. There are no means to verify the accuracy of these renderings, but both still convey a flavor of excitement. As Planet and Conagree pass the half-mile pole, one can see Grinnell's Hotel in the distance. (*Frank Leslie's Illustrated Newspaper.*)

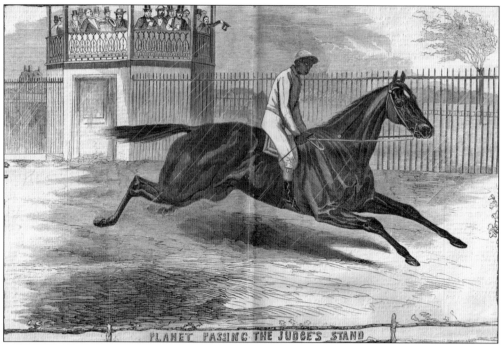

PLANET CLOSE-UP. Captured in this artist's rendering for *Frank Leslie's Illustrated Newspaper*, dated October 6, 1869, is the horse Planet, a taut and vibrant specimen whose gallop drew favorable attention. From the looks of it, Planet impressed those watching from the judge's stand.

NOT TO TROT. No, this is not a jockey (and not a trotter), but a photograph of Joseph Bennett, owner of a prominent grocery and vegetable store located at the southeast corner of National and Roosevelt Avenues. In this undated photograph, he and his rig are actually on the Fashion Race Course. The track is in the immediate foreground before the grass—note how it just begins to curve. Note also the fencing in the background that runs alongside the circuit.

Five

FLUSHING MEADOWS

Separating Corona on its eastern outskirts from Greater Flushing are the meadows. For many residents, Flushing Meadows-Corona Park is where families enjoy barbecues, play soccer and cricket in the hot summer months, enjoy performances at Queens Theater in the Park, visit the Queens Zoo, experience arts and culture at the Queens Museum, and make new discoveries at the Hall of Science.

This vast area encompassing more than 800 acres stretches from 111th Street to Flushing Creek and from Flushing Bay to the Long Island Expressway. The parkland has been reincarnated many times in its long history. It is home to the New York Mets, who play at Citi Field, as well as the US Open (for tennis), and was even the site of two world's fairs in 1939–1940 and 1964–1965. But before the stadiums, the fairs, the museums, and the zoo, it was simply called "the meadows."

It began as a vast tidal marsh covered with a thick growth of swamp grass that camouflaged dozens of small streams and brooks, which branched and made a serpentine pathway through the open and lonely territory. The most incredible and bizarre chapter in the life of the meadows would last for 30 years, beginning in 1907. That was the year Michael Degnon, builder of the Williamsburgh Bridge and the Degnon Terminal in Long Island City, began buying up every available tract of marshland to fill in to construct a foundation for what he envisioned as the most advanced barge canal created with a great port facing Flushing Bay.

Together with the City of New York, a contract was established calling for the removal of chimney ashes and street sweepings (garbage and horse manure) from Brooklyn. The ashes were collected from thousands of homes in Brooklyn, and even dirt and rock excavated from the expansion of the Brooklyn subway system were used. By 1911, more than 20 carloads carrying 1,000 cubic yards of ash and sweepings were dumped into the meadows daily.

Looking from the air, the meadows run in a vertical swath south from the mouth of Flushing Bay to where the Flushing Creek terminates in Kew Gardens. As Corona developed into a thriving neighborhood, the "Corona Ash Dumps," as they would be called, became an overwhelming problem in the lives of the people who lived along its polluted border. The stench of rotting garbage decomposing in the summer heat could be smelled throughout Corona and nearby Flushing, forcing residents to close their windows.

By 1914, so much ash had accumulated that it began creeping its way toward populated Corona, and by 1915, the city gave Degnon the go-ahead to fill in the entire meadows, stopping at Northern Boulevard. The collection of ash grew to such heights that a 100-foot mound located near 111th Street and Forty-sixth Avenue was nicknamed "Mount Corona." Within a decade, 8 to 10 million cubic feet of ash had been dumped. It would take legislative reform and the vision of city planner Robert Moses to bring the world's fair to New York City to have the ash dumps finally cleared.

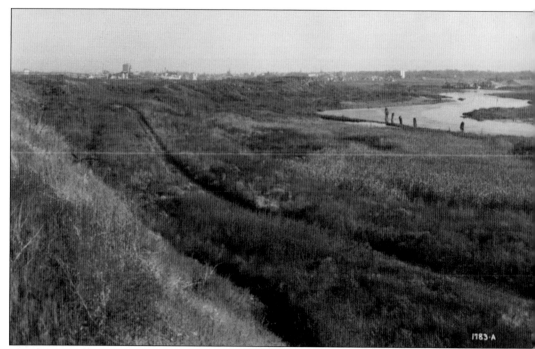

PANORAMA OF THE MEADOWS. Taken on November 9, 1935, looking north toward Flushing, this amazing panorama shows the expanse of Flushing Meadows in the years before the New York

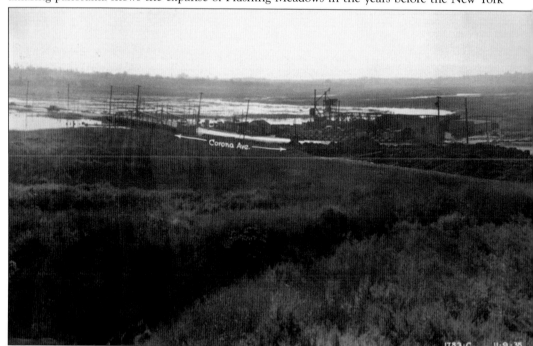

PANORAMA LOOKING SOUTH. While parts of the area were pristine, other sections made the dramatic transition from swamp and salt meadow to being covered in ash. Brooklyn Ash Removal Company overseer John A. "Fishhooks" McCarthy was known for his no-nonsense and meticulous approach. "Fishhooks" would sit on an old rocking chair and tally each carload of debris that came

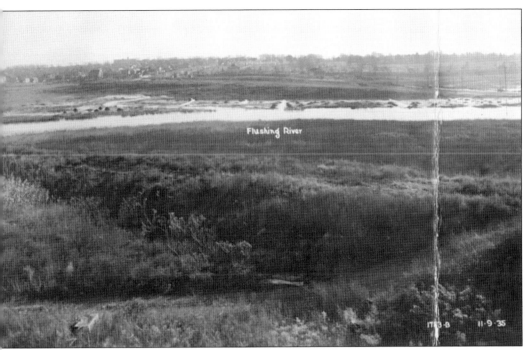

World's Fair, with the Flushing River snaking its way south toward Corona and Jamaica. Sections of the meadow are still untouched by man.

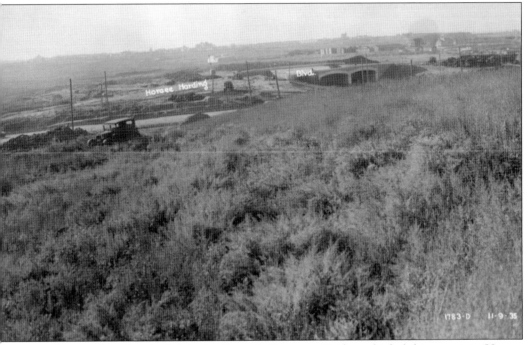

into the meadow. On the left is the Strong's Causeway Bridge, which fed its way into Horace Harding Boulevard on the right. The Long Island Expressway would absorb both the causeway and the boulevard a couple of years later.

THE TALCUM POWDER EXPRESS. This is a rare image of a Brooklyn Ash Removal Company transport train arriving in the meadows via the Port Washington line on the LIRR. With the acronym for the company name, BARCO, painted on its side, the train would deliver the ash to the meadows pulling specially made wooden gondolas. Within a decade, 8 to 10 million cubic feet of ash had been delivered to the meadows via these special trains. Although a public ordinance required each gondola to be covered by a tarpaulin, a cloud of white dust always filled the air as the train rumbled by. Thus, the train became known as the Talcum Powder Express. It was discontinued in 1934. (Queens Borough Public Library, Archives, Eugene L. Armbruster Photographs.)

MOUNT CORONA. This bleak image taken in July 1936 shows the 100-foot mound of ash that would be nicknamed Mount Corona by local residents. Shop houses and vehicles of the Brooklyn Ash Removal Company sit in its shadow.

A Dismal Scene. The epicenter of the ash dumps is seen here at the base of Mount Corona. Mixed in with the ash are garbage, scrap metal, and additional refuse. Downtown Flushing stands in the distance. (Queens Borough Public Library, Archives, Eugene L. Armbruster Photographs.)

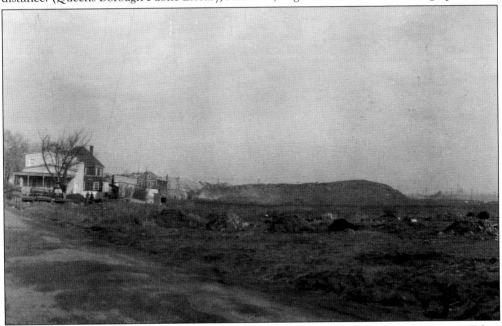

The Corona Dumps. By 1922, the ashes began to encroach upon the outskirts of Corona. Taken from Colonial Avenue (108th Street) looking north, this photograph shows the old William Geyer hotel along with several newer additions along Mill Creek with ashes literally at their doorstep. Mount Corona rises ominously in the distance. (Queens Borough Public Library, Archives, Eugene L. Armbruster Photographs.)

A Farm Grows in the Ashes. By the 1920s, the ashes were reaching the residential sections of Corona. Ugly and malodorous to many, there were a few who used the dump to their advantage. A number of Italians from Corona Park rented sections of the dumps, as shown in this photograph, to be used as small vegetable gardens. Incredibly, the manure- and garbage-filled soil proved extraordinarily rich and yielded a good harvest of produce sold on the streets of Corona and Flushing. (Queens Borough Public Library, Archives, Eugene L. Armbruster Photographs.)

Other Industries in the Meadows. The meadows were home not only to the ash dumps, but also to other industries as well, including a coal repository seen here along Horace Harding Boulevard (today's Long Island Expressway). The Strong's Causeway Bridge can be seen in the center of this photograph dated June 25, 1935, looking eastward.

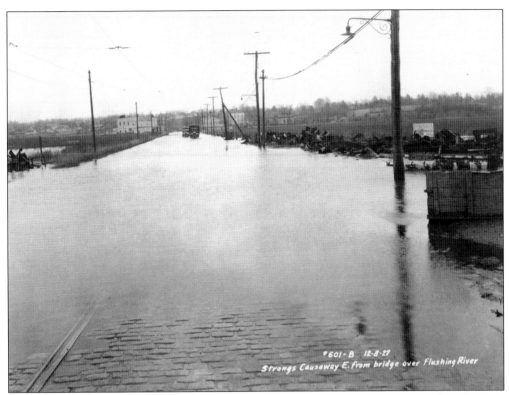

601-B 12-8-27
Strongs Causeway E. from bridge over Flushing River

WASHOUT. Without adequate sewer lines or drainage systems, the area surrounding Strong's Causeway was prone to flooding. The situation would sometimes get so bad that trolleys would get stranded for hours, and passengers would have no choice but to wait for the water to recede.

A SERIOUS PROBLEM, 1927. During winter storms known as nor'easters, commuters would have a difficult time crossing the meadows, especially at high tide when the Flushing River would overflow onto the roadway, in this case Northern Boulevard west of the Flushing Bridge. Making matters more perilous are the overhead electrical and telephone wires, which were vulnerable to collapse. (Queens Borough Public Library Archives, Borough President of Queens Collection.)

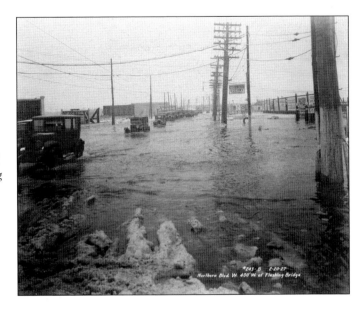

243-B 2-20-27
Northern Blvd. W. 400'W. of Flushing Bridge.

THE CORONA PARK GOLF COURSE. The one and only golf course to ever exist in Corona was the Corona Park Golf Course. This course was the joint venture of Col. Charles R. Van Etten, president of the Brooklyn Ash Removal Company and Queens borough president George U. Harvey. The 18-hole course was built in 1931 and occupied 127 acres surrounded by the ash dumps along Roosevelt Avenue. The Colonial-style clubhouse and main entrance faced 111th Street. The club was opened to the public on a membership basis. Although it ran at a profit for its first three years, it went out of existence when the Grand Central Parkway was laid out, cutting off two fairways, and the city bought up the remaining parcel. It closed on August 2, 1934.

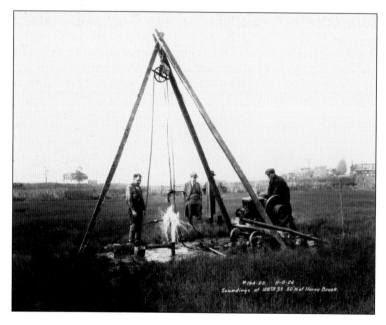

TAPPING THE BROOK AT 108TH STREET, 1926. Pictured here are the waning days of the Horse Brook before it would disappear all together as a result of development. Engineers from the Queens Topographical Bureau oversee testing of the marshland's depth to determine how suitable it was for the expansion of roads and development of future infrastructure.

UNDER THE COVER OF DARKNESS. Work on the ash dumps would continue well into the night. More than 50 laborers, all wearing goggles, handled 60 carloads of ashes and refuse delivered every night. Garbage and other refuse would be incinerated nonstop during the night, causing an eerie glow to emanate from the meadows. This rare image taken on the night of July 23, 1936, shows that process as seen from the Corona side.

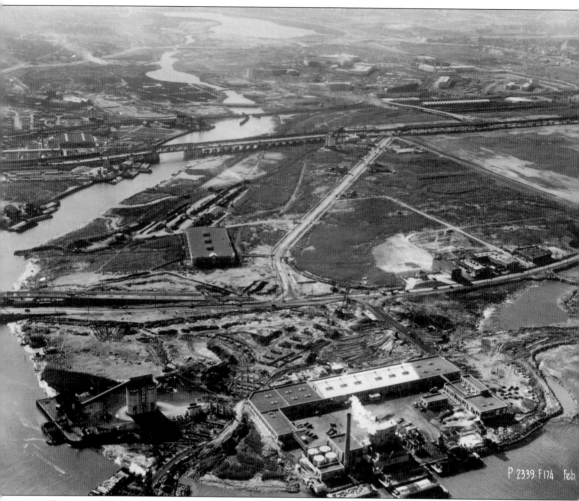

FLUSHING MEADOWS FROM ABOVE, FEBRUARY 1938. The remaining industrial legacy of the meadows was now isolated to its northernmost terminus. That section, near Roosevelt Avenue, would be called the Iron Triangle due to the large number of vehicle repair shops and scrapyards. Also situated there were coal pocket silos and asphalt plants. In the far background, the ash dumps are gone, and the early construction of the pavilions for the 1939–1940 New York World's Fair is under way. (Queens Borough Public Library, Archives, Borough President of Queens Collection.)

Six

CORONA BY THE BAY

One of the many forgotten chapters in Corona's history took place on its outskirts near the Flushing Bay. It was here that numerous seaside pavilions and resorts once existed, as well as swimming and yacht clubs, in the days when the water was clean and before the coming of the Grand Central Parkway, which eliminated the entire shoreline from Corona all the way to Flushing. There were many attractions to choose from, including Fischer's Bathhouse or Wenzel's, Harry Hill's, or the amusement park at North Beach. Why bother going to Coney Island or the Rockaways for that matter? It was too far and too expensive. With adequate trolley service, the Corona seaside was easily accessible for many residents, who enjoyed everything they could expect from these seaside resorts. Pollution from dredging in the bay, the dumping of ash and garbage in Flushing Meadows, and the disposal of garbage near Riker's Island just south of the Bronx, opposite of Corona and Flushing, brought about an end to most of these long-forgotten pleasure grounds.

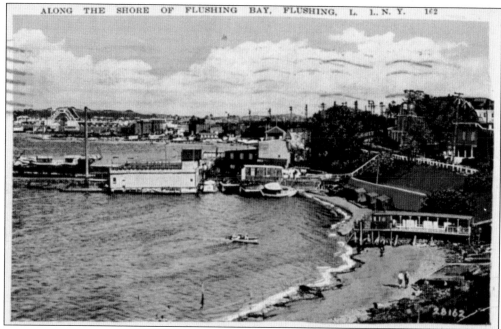

A GRAND VIEW. Pictured here is the Corona shoreline during the height of its popularity as a seaside resort. Wenzel's Bathing Pavilion is in the foreground along with a few yacht clubs. In the far distance on the left is the Roosevelt Avenue drawbridge of the IRT No. 7 train in the open position. Today, not a single structure along the seashore remains, long covered over by the Grand Central Parkway.

BOWERY BAY, 1900. The first European settler to the west of Corona was Hendrick Harmensen in 1638. He was killed in a raid with the local natives, the Matinecock, in 1643. After his death, the Dutch Reformed Church bought his farm in 1654 to establish maintenance for their poor, hence it was called "Armen" or "Poor Bowery." In later years, it was changed to Flushing Bay to avoid confusion with the notorious Bowery in Lower Manhattan. To the right, jutting out into the bay is the area known as North Beach, a seaside amusement park that once rivaled Coney Island. It is today's LaGuardia Airport. (LaGuardia and Wagner Archives.)

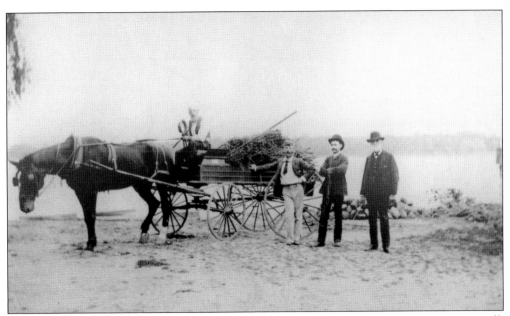

WORKING BY THE BAY. Flushing Bay was not only a place for recreation, but for enterprise as well. Ships and barges transferring and delivering goods were a common sight along the waterfront in the 19th and early 20th centuries. Fishing, clamming, and collecting salt hay was also common.

THE ICEMAN SAVETH. Corona men pose with an early-20th-century apparatus used to save those unfortunate enough to fall through the ice on Flushing Bay.

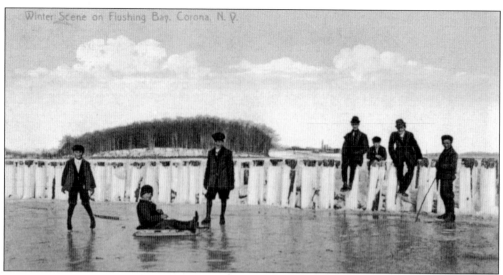

St. Ronan's Well. The main focus of this postcard is not only the youngsters on ice skates, but also the wooded area in the background. This 12-acre area was known as St. Ronan's Well, a high bluff overlooking the bay. Covered by a dense growth of trees, the land also known as Yonker's Island was situated south of Northern Boulevard near 126th Street, where present-day Citi Field is located. *Yonker* is the Dutch word for "gentleman" and was used as a tribute to the owner of the land, Adrien Van der Donck. Afterward, it was known as Snake Hill. At high tide, it would become completely surrounded by water. Purchased by a sand-mining company in the 1880s, it was leveled and erased from existence by 1898.

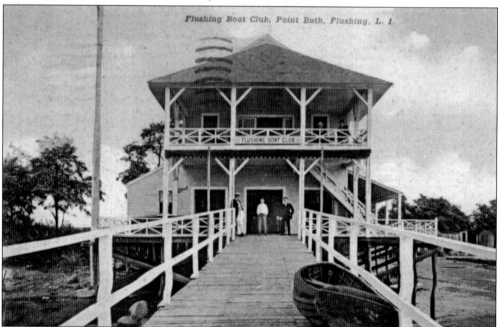

Flushing Boat Club. The late 19th century saw a rise in the popularity of yachting and rowing clubs. These clubs from Flushing and Corona would often compete with one another. The matches were met with great fanfare and were a cause of much celebration in the town. The pride of Flushing was the Seawanhaka Boat Club.

HARRY HILL. It was 1870 when Harry Hill came to Corona, buying the three-acre farm and grand estate once owned by Samuel C. Jackson overlooking Flushing Bay. Hill was born in 1827 in the small village of Epsom, England, home of the famous Epsom Downs racecourse. At age 21, Hill met a wealthy American at the track named George M. Woolsey, who was a partner in a lucrative sugar firm. Woolsey, who lived in Astoria, became friendly with Hill and offered him a position as manager of his stables back home in Queens. Hill accepted, landing in Flushing in 1850. After working for Woolsey for two years, Hill ventured into the saloon business.

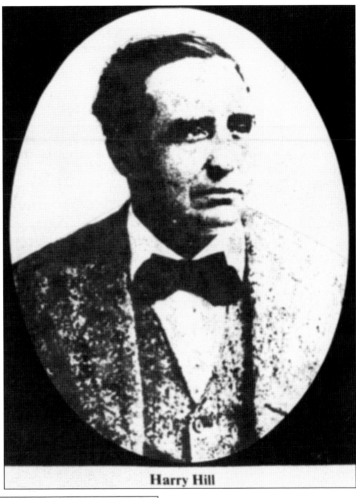

Harry Hill

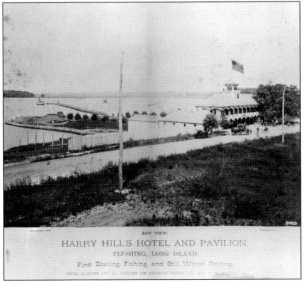

BAY VIEW.
HARRY HILL'S HOTEL AND PAVILION.
FLUSHING, LONG ISLAND.
Fine Boating, Fishing, and Still Water Bathing

HARRY HILL'S BAY VIEW HOTEL AND PAVILION. After his success in Manhattan and with the Hoffman House at Northern Boulevard and 123rd Street, Harry Hill opened his grand Bay View Hotel and Pavilion along Northern Boulevard (near where the World's Fair Marina stands today) on October 14, 1879. Here, Hill hosted events, including boxing matches, wrestling contests, and afternoon chowder luncheons held on the second floor. Guests at the pavilion were entertained by Hill's antics, which included the purchase of a pet bear he named Bruin. The bear would greet guests and even guzzle down beer, sarsaparilla, and soda water.

HARRY HILL'S LOOKING EAST. Looking east from a point near Northern Boulevard and 117th Street along the shoreline, Harry Hill's Bay View Hotel and Pavilion is seen in its heyday with a commanding view of the Flushing Bay. In the background is St. Ronan's Well. The atmosphere at Hill's pavilion was festive to say the least, yet he was aware that the clergy of Flushing and Corona objected to his sometimes rough and rowdy ways. Upon entering the establishment, Hill suspended a set of rules indicating that no incident or boisterous conduct or profane swearing was permitted as well as no thieving or violence of any kind. Those who acted contrary to the rules met the physical wrath of Hill, himself a trained boxer.

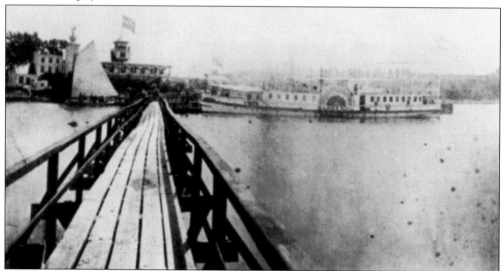

EVERYONE COMES TO HARRY'S. In order to guarantee the success of the Bay View Hotel and Pavilion, the ever-resourceful proprietor Harry Hill chartered a steamboat conveniently called *Bay View* in April 1880, making two trips daily from Wall Street in Manhattan. Later that year, Hill purchased the steamer *E. Morris*, which made its maiden voyage on May 16. The steamer proved to be a huge financial success for Hill, for it not only carried passengers, but freight as well. In 1882, he purchased another steamer and named it *Harry Hill*. It featured a side-wheel paddle and was the fastest steamer in the area. From this the man who already wore many different hats was nicknamed "Commodore Harry Hill."

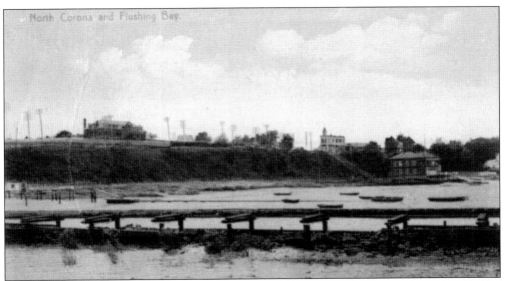

NORTH CORONA FROM FLUSHING BAY. This postcard offers a view of how the northern bluff of Corona appeared to people on Flushing Bay. Dr. Combes's sanitarium is visible on the left, and the cupola of Holt's Flushing Bay Hotel can be seen on the right.

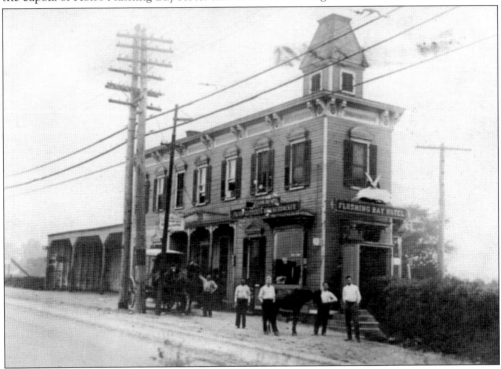

FLUSHING BAY HOTEL. Built by Clifford Holt in the early 1890s, the Flushing Bay Hotel was located at the split between what is today Northern Boulevard (Jackson Avenue) and Astoria Boulevard (Flushing Avenue). It was two stories tall, had an incredible view of the Flushing Bay, and featured a dozen rooms. On the first floor, guests could enjoy themselves at Jacob Ruppert's Knickerbocker Saloon. The hotel was best known for its pigeon-shoot competitions held every year. Next to the hotel were carriage houses for horses and buggies.

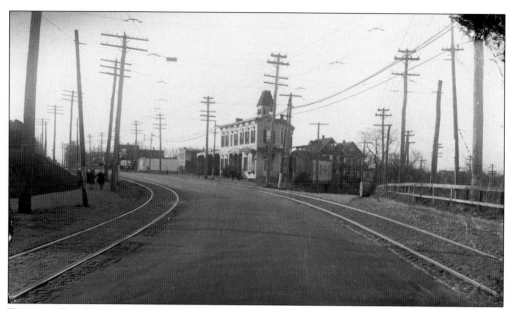

FLUSHING BAY HOTEL, 1915. Built on property once owned by Harry Hill, the Flushing Bay Hotel would close some time after World War I. Owner Clifford Holt was killed on November 30, 1915, in an automobile accident on Seventy-second Street in Manhattan after his car, chauffeured by one Charles Peterson, flipped over in a freak accident. The hotel is shown here in this gorgeous photograph by Frederick J. Weber, taken the year that Holt was killed. (Queens Borough Public Library, Archives, Frederick J. Weber Photographs.)

A QUIET COUNTRY LANE. Before the loud traffic of cars, buses, and trucks, Astoria Boulevard was a dirt-covered road formerly known as Flushing Avenue. This peaceful autumnal scene in 1907 captures two horse-drawn carriages with the Samuel C. Jackson home silhouetted on the hill to left in the background. Steps leading to Wenzel's Bathing Pavilion and Beach would be on the right.

FLUSHING AVENUE. Looking in the opposite direction of the previous image is Astoria Boulevard in the days when it bore the Flushing Avenue name. It was originally a wooden plank road.

FRIENDS AND FAMILY. This charming 1910 photograph shows a small grouping of friends and neighbors before going out for a swim in Flushing Bay. The thoughtful little boy on the first row at the far right is future chronicler of the area, William Coughlan (see Introduction). The woman seated behind him with the wide smile is his mother, Elizabeth.

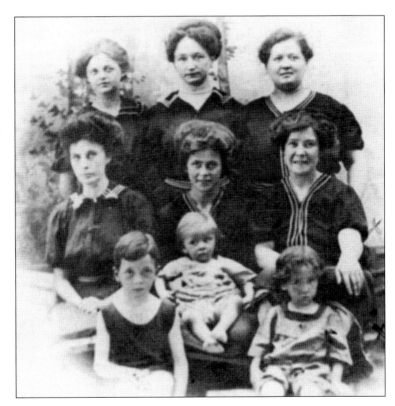

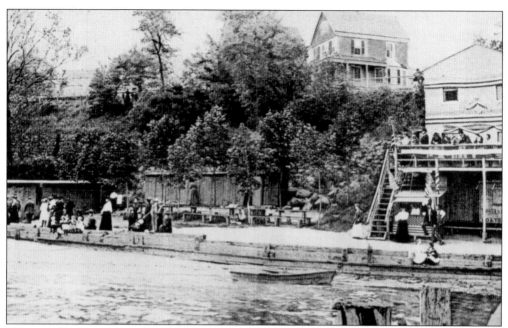

Wenzel's Bathing Pavilion. The largest and most popular spot for bathing was operated by actor and Corona resident Frederick Wenzel. In 1911, the board of health demanded that all bathhouses and swimming pavilions install sterilization plants for bathing suits and towels. With the Depression and growing pollution in Flushing Bay, Wenzel's faded into memory.

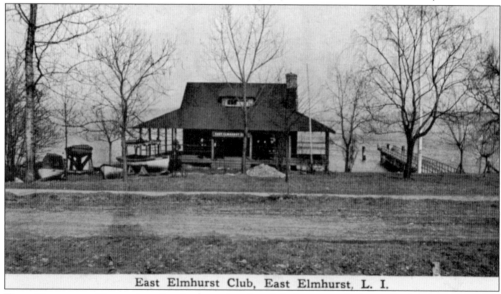

East Elmhurst Club, East Elmhurst, L. I.

East Elmhurst Club. Another boat and swim club frequented along the bay was the East Elmhurst Club. The small two-story clubhouse rented out boats for rowing and featured a clean beach for bathing. In 1917, the local authorities limited swimming west of Douglaston due to water pollution. This should have caused the club to suffer the fate of its neighboring competitors. Miraculously it survived and was reinvented as a social club that lasted through World War II. Little else is known about the club, but its location can be found on many period maps at what is today Ditmars Boulevard and Twenty-seventh Avenue.

GREETINGS FROM CORONA. This beautiful pastel postcard featuring an attractive patriotic Gibson Girl was used as a generic greeting card. The blank space at the bottom was used to fill in whatever town or city it was mailed from. This particular postcard was sent from North Beach in 1907. (Michael Perlman and the Rego-Forest Preservation Council.)

NOCTURNAL SAILING. In this dreamlike postcard scene, rare because it is an image portrayed at night, one can see a skiff placidly making a nocturnal excursion into Flushing Bay. This no doubt appears to be a close-knit group of friends who sought to take advantage of a summer evening to set sail, or even fish, beneath the moonlight.

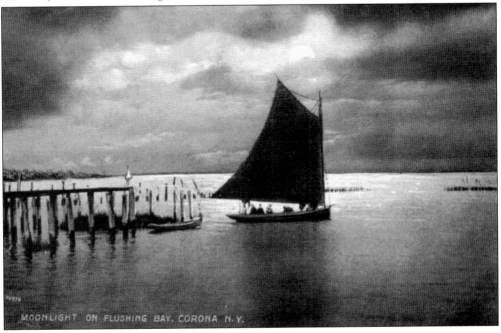

MOONLIGHT ON FLUSHING BAY. CORONA N.Y.

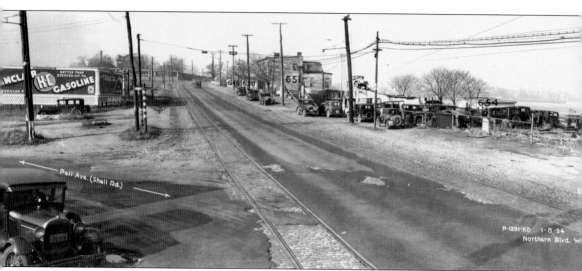

THE SHORELINE'S FINAL DAYS. By the time this photograph was taken on January 8, 1943, looking west along Northern Boulevard, the shoreline bathing pavilions had all gone out of business due to the Great Depression and increasing pollution in Flushing Bay. To the left is Pell Avenue (formerly the Shell Road). This was the year that also marked the beginning of construction on the Grand Central Parkway, which eliminated all the seaside attractions. The shoreline was altered with more than 300 feet of landfill added to accommodate the new parkway. Now the generations of summer fun and history lie buried beneath layers of asphalt. (Queens Topographical Bureau.)

Seven

THE GENIUS OF LOUIS COMFORT TIFFANY

The most celebrated product ever manufactured in Corona was the world-famous Tiffany glass. Born in New York City on February 18, 1848, Louis Comfort Tiffany brought his factory to Corona in 1893. It was here at the corner of Kingsland Avenue and Luydig Place (Forty-third Avenue and Ninety-seventh Place, respectively) that Tiffany, along with business partner Arthur J. Nash, a former manager of the Webb Glass Works in Stourbridge, England, set up the Stourbridge Glass Company as a division within the Tiffany firm. Many of the original employees hailed from Boston, Massachusetts, and Sandwich, England.

On April 7, 1893, Stourbridge and Tiffany became incorporated. The facility would not last for long, however, for it was destroyed by fire on October 28, 1893. Tiffany erected a better factory, one of concrete and brick, soon after. By the close of the 19th century, the furnaces were producing many of the signature glass lamps that became known throughout the world. In 1891, Joseph Briggs (1873–1937) emigrated from Liverpool, England, to New York City and in 1902 was appointed head of the mosaic department, overseeing production of Tiffany mosaic glass.

In 1902, Tiffany reorganized Stourbridge as the Tiffany Furnaces. The height of popularity for Tiffany and his Corona factory occurred just before World War I. Soon after, the factory expanded. In 1919, Briggs was appointed a trustee of the Lewis Comfort Tiffany Foundation and in 1920 was appointed director of Tiffany Studio's after Tiffany's retirement. In his will, Tiffany stipulated for the company to be liquidated if Briggs ever became ill or infirmed. A little-known yet significant fact in the legacy of Tiffany glass was that the company's most iconic pieces were designed and executed by Clara Wolcott Driscoll. Born in Tallmadge, Ohio, in 1861, Driscoll showed a talent for art and design from a young age. She attended the Western Reserve School of Design for Women (now Cleveland Institute of Art) and enrolled in the Metropolitan Museum Art School. In the 1880s, Tiffany Studios in Manhattan hired her. For the next two decades, she designed lamps, mosaics, windows, and other decorative works. As a leading figure in the Tiffany lamp division, Driscoll designed and crafted more than 30 lamp designs, including the famous dragonfly lampshade and daffodil mosaic.

The facilities closed in 1938, and the Roman Bronze Works occupied the building for sometime after. It was demolished in 2013 to make way for a public school.

THE INCOMPARABLE TIFFANY. Born in New York City on February 18, 1848, Louis Comfort Tiffany brought his factory to Corona in 1893. (Library of Congress.)

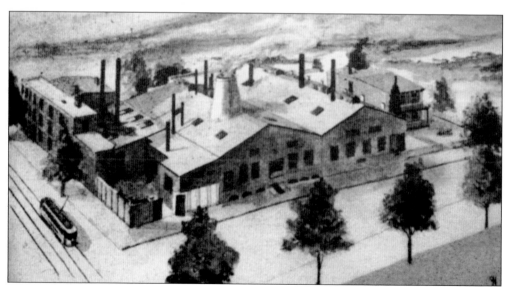

THE FIRST FACTORY. The original Corona factory is shown in this sketch published in the firm's pamphlet titled "Tiffany Favrile Glass."

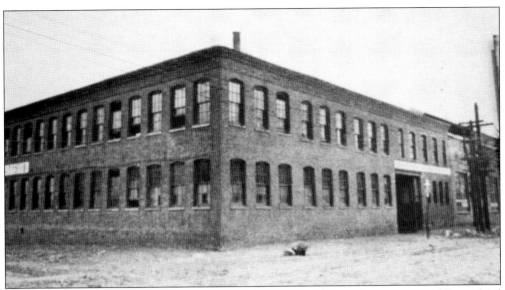

THE CORONA FURNACES. The two-story redbrick facility at the northwest corner of Forty-third Avenue and Ninety-seventh Place housed the furnaces and workshops from which some of the most famous glass creations in the Tiffany line were born.

ORNAMENTAL BRONZE AND IRONWORK. This 1920s advertisement for the Tiffany Studios shows the many additional products made at the Corona furnaces, including ornamental bronze and iron work for vestibule doors, gates, candelabras, chairs, elevator fronts (doors), and even the cars themselves.

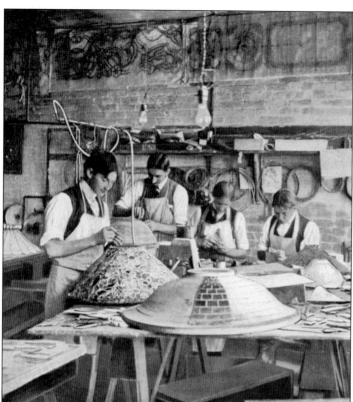

MASTER CRAFTSMEN. Artisans pay careful attention as they go about their painstaking work inside the lamp shop at Tiffany Studios. (*Cosmopolitan* magazine.)

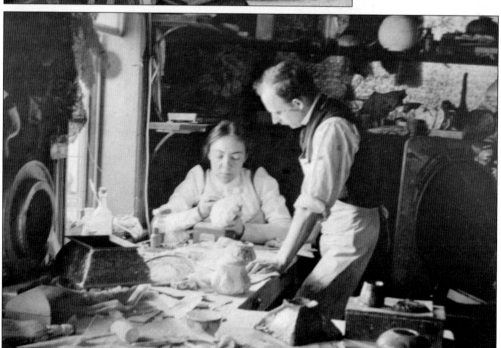

LEGENDS OF TIFFANY. Clara Wolcott Driscoll (left) and Joseph Briggs (right) are pictured here in 1902 in Driscoll's workroom at the Tiffany Studio.

No Alcohol, No Peace. When the men of the Tiffany furnaces' cabinetmaking department were informed that their beer privileges were to be curtailed, they threatened a massive strike. As reported in the March 14, 1903, issue of the *Brooklyn Daily Eagle*, the workers received news that "No beer or spirituous liquors are allowed on the premises from 8 to 12 or from 1 to 6." An emergency meeting was called for at C. Siemer's Hotel, near the studio, where the Cabinet Makers Local Union No. 309 and Pres. Paul Singer agreed to strike if men were further prohibited from bringing beer into the shop. (*Brooklyn Daily Eagle.*)

Men at Work. This rare 1903 photograph shows the soot-laden workers of the furnaces and brass works division. A stark contrast to the more agreeable surroundings experienced by the artisans and designers, the men of the blast furnaces worked in more demanding conditions that involved many hours of labor in front of the hot kilns. The factory was shut down every July for cleaning and maintenance of the furnaces. In 1938, operations came to an end. (Vincent F. Seyfried Collection.)

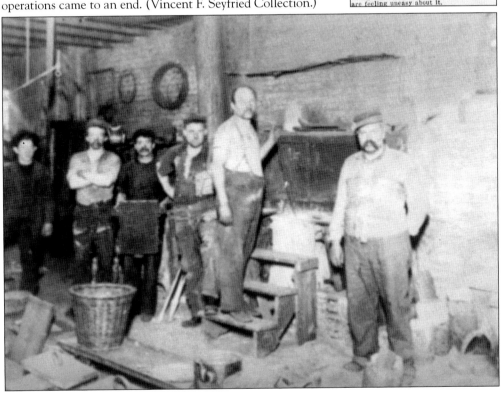

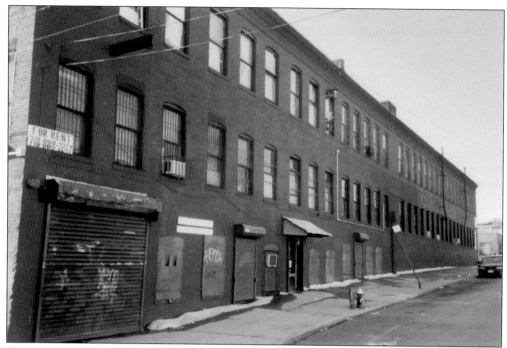

TIFFANY GLASSWORKS. The Corona studio would survive almost 120 years before being demolished in 2013. The new public school that will rise in its foundation will feature a tribute to Louis Comfort Tiffany and his glassworks.

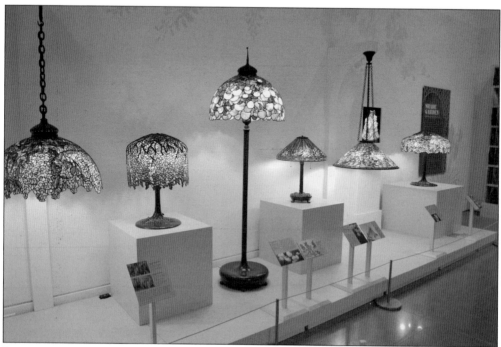

LEGACY. Fine examples of original Tiffany lamps are on display at the Queens Museum's exhibit on Tiffany and the history of the Corona factory. (*Western Queens Gazette.*)

Eight

CORONA ON THE EVE OF THE WORLD'S FAIR

The 1939–1940 New York World's Fair was a seminal event for Queens, for all of New York City, and for the entire country. Much to the borough's everlasting pride, the world's fair has earned a lasting place in America's social narrative.

It was this singular event that served as a last period of major transition and officially brought Queens into the 20th century. Although many neighborhoods had been fully developed and established by 1939, the coming of the fair stimulated this final push for modernization, which saw the renovation and creation of roads and major arterial highways, including the widening of Northern Boulevard, the completion of the Grand Central Parkway, and the beginning of the Long Island Expressway and the Queens Midtown Tunnel.

With the elimination of the ash dumps and the rise of the glistening pavilions of the world's fair, Corona took on a new identity. No longer would people see Corona in light of its former ash dumps and the workings of Fishhooks McCarthy.

Queens was always something of a mosaic, as each of its communities has a story to tell while helping to forge Queens into a place that can even inspire. This would continue after Queens officially became a city borough in 1898. After the miasma of burning ash in Flushing Meadows finally cleared, Corona did its part. It was instrumental in conveying to the rest of the world the promise of better times to come. The contrast of the past and future was never more crystalline. Likewise, neither was Corona.

THE DUMP'S FINAL HOURS. At long last, the final remains of the once notorious Corona Dumps came to pass in 1938, a time many residents felt would never come in their lifetimes. The removal of the loathsome ash that had accumulated for decades was but the first step in building the 1939–1940 New York World's Fair. The gesturing man with his back to the camera is unidentified, though the authors speculate that he is none other than Robert Moses, complete with fedora, waving goodbye to the nightmarish scene, which to him symbolized the decay of the old order. As is well known, it was Moses who moved mountains, as it were, to bring the fair to reality.

OTHERWORLDLY. What at first glance looks like the landscape of some distant planet is actually the beginning stages of the westbound Grand Central Parkway. The distant overpass is part of a cloverleaf roadway that accommodates the Long Island Expressway. Mount Corona menacingly looms beyond the overpass. This eerie image was taken in 1936.

A Needed Accommodation. By the time this busy photograph was taken in 1938, the IRT subway was already a fixture in Queens. Because this line conveniently ran parallel to the site of the world's fair, common sense required the construction of a ramp for subway arrivals.

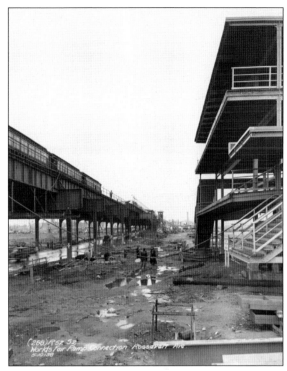

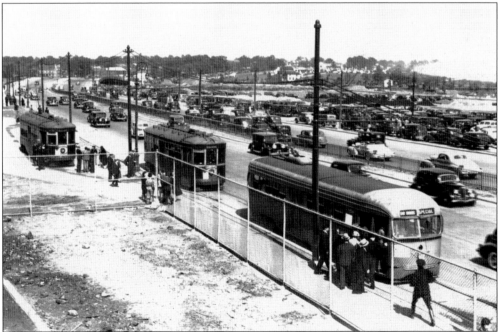

Early Rush Hour Scene, 1938. This is a rush hour scene on Horace Harding Boulevard—which evolved in the late 1930s into the Long Island Expressway—as viewed from the standpoint looking east near Strong's Causeway half a century before. The rush of commuters heading toward their respective trolleys is quite similar to what takes place today with the MTA bus lines. The trolleys are taking passengers to a special preview of the world's fair grounds.

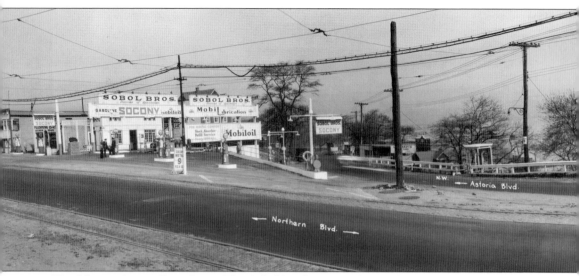

THE MOTOR AGE IN FULL GEAR. The Sobol brothers owned several gas stations in the Flushing, Corona, and north Queens area. This one station located in the split between Northern and Astoria Boulevard stands in the former location of the Flushing Bay Hotel, seen on page 109.

TRYLON AND PERISPHERE GROUND-BREAKING. Here was the future site of the Trylon and Perisphere, the iconic symbols of the 1939–1940 New York World's Fair. As the patriotic display and mass of released balloons signify, the crowd on hand eagerly anticipates their construction, and with that quite possibly the promise of the World of Tomorrow as well. The Trylon and Perisphere were widely acknowledged for the duration of the fair and would later assume a special place in the social history of America.

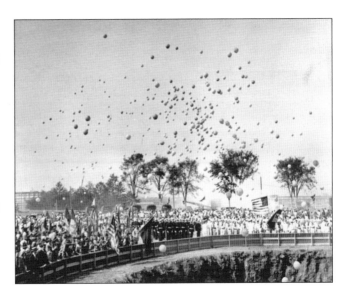

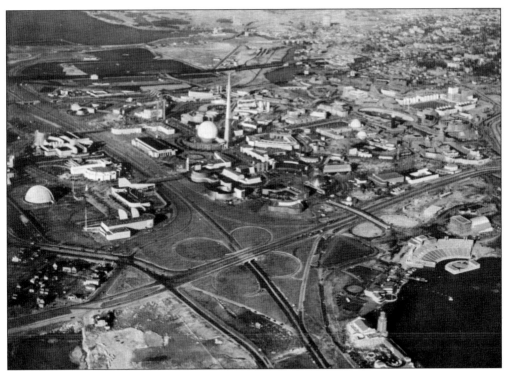

A RESPLENDENT WORLD'S FAIR. The Flushing Meadows reemerged from a grim period into a dazzling spectacle that captured the world's attention. It was nothing short of a miraculous transformation. The newly laid arterial highways, including the Grand Central Parkway, extend diagonally through the fairgrounds. Running alongside it from the bottom left is Corona Avenue with Horace Harding Boulevard (formerly Nassau Boulevard and presently the Long Island Expressway) cutting through the scene. To the left of the Perisphere is the New York City Pavilion, which in 1946 would serve as the first location of the United Nations. (Fairchild Aerial Photo Service.)

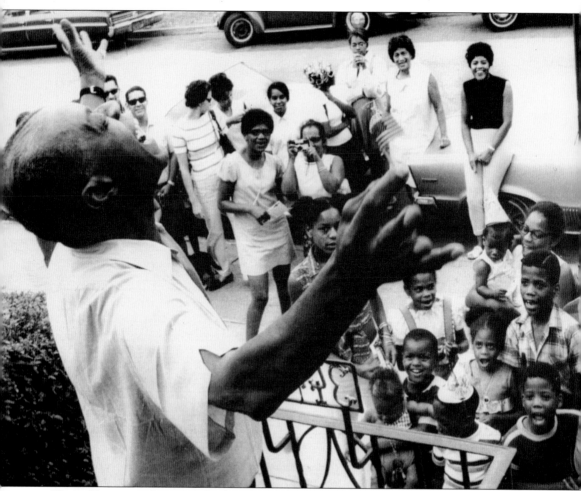

Happy Birthday, Satchmo. In this photograph taken in 1969, an exuberant Louis "Satchmo" Armstrong at his home in Corona greets neighborhood children and their parents who came to wish him well on his 67th birthday. Lucille and Louis Armstrong moved to Corona in 1943 after Lucille surprised Louis with the purchase of the house while he was away on tour. For nearly 28 years, until Louis died in 1971, the Armstrongs called 34-56 107th Street home. Lucille passed away in 1988. The house was declared a National Historic Landmark in 1977; since 2003, it serves the public as the Louis Armstrong House Museum, operated by the City University of New York's Queens College in accordance to the wishes expressed in Lucille Armstrong's will. Though it technically steps out of the stated timeline for this book, this wonderful image illustrates that communities like Corona have always tended to bring out the best in people. (United Press International.)

BIBLIOGRAPHY

Brooklyn Daily Eagle, www.bklyn.newspapers.com

Kroessler, Jeffrey A. *Lighting the Way: The Centennial History of the Queens Borough Public Library 1896–1996*. Virginia Beach, VA: Donning Company, 1996.

Kross, Jessica. *The Evolution of an American Town: Newtown, New York 1642–1775*. Philadelphia, PA: Temple University Press, 1983.

Mandeville, Dr. Henry G. *A Historical Sketch*. Flushing, NY: Home Leture Committee of 1857–1858, 1860.

Munsell, W.W. *History of Queens County*. New York, NY: self-published, 1882.

Riker, James, Jr. *The Annals of Newtown in Queens County, New York*. New York: D. Fanshaw, 1852.

Seyfried, Vincent F. *The Story of Corona*. Hicksville, NY: Edgian Press, 1986.

Skal, George Von. *An Illustrated History of the Borough of Queens New York City*. New York, NY: F.T. Smiley Publishing Company, 1908.

DISCOVER THOUSANDS OF LOCAL HISTORY BOOKS FEATURING MILLIONS OF VINTAGE IMAGES

Arcadia Publishing, the leading local history publisher in the United States, is committed to making history accessible and meaningful through publishing books that celebrate and preserve the heritage of America's people and places.

Find more books like this at
www.arcadiapublishing.com

Search for your hometown history, your old stomping grounds, and even your favorite sports team.

Consistent with our mission to preserve history on a local level, this book was printed in South Carolina on American-made paper and manufactured entirely in the United States. Products carrying the accredited Forest Stewardship Council (FSC) label are printed on 100 percent FSC-certified paper.